A SHORT HISTORY OF
RICHMOND

A SHORT HISTORY OF
RICHMOND

JACK TRAMMELL & GUY TERRELL

THE
History
PRESS

Published by The History Press
Charleston, SC
www.historypress.net

Cover images courtesy of the Library of Congress.

First published 2017

Manufactured in the United States

ISBN 9781625859570

Library of Congress Control Number: 2017953982

CONTENTS

FOREWORD

One particular episode of *The Andy Griffith Show*—"Stranger in Town"—concerns an unknown man named Ed Sawyer who arrives in Mayberry and, despite never having set foot there, knows as much about the town and its residents as those who have spent their whole lives there. Disturbed by the ease with which this total stranger fits in, the lifelong Mayberrians let their minds wander and speculate as to what Ed might be: a criminal, a foreign spy, maybe even a creature from the supernatural world. The townspeople eventually frenzy themselves into a mob and confront the peculiar newcomer. Frazzled and frightened, Ed explains that he first heard about Mayberry from an army buddy who had grown up there. His friend's stories and a subscription to the local newspaper taught Ed all about the kindly southern town and its residents over the years, and his innocent fascination with the place grew so great that he decided to move there and declare, "Mayberry is my hometown."

Ashamed of their previous suspicion of Ed, the Mayberrians by birth resolve to welcome this Mayberrian by choice, with Sheriff Andy observing, "Out of all the towns, he picked Mayberry to be his hometown. It looks like to me you'd be proud to have a fellow think so much of you to want to come settle down and live amongst you."

The differences between Mayberry and Richmond—size, demography, culture—are too numerous to list entirely, but, as a Richmonder by choice, I feel a sort of kinship with Ed Sawyer. I was born in St. Paul and grew up in the Kansas City area. In law school, I met a Richmonder named Anne,

married her and settled down to start a family with her in this city. Rather than meeting me with suspicion, the people of Richmond immediately welcomed me as one of their own. Over the years, my neighbors have given me the privilege to serve on city council and as their mayor, and they have supported me in my state and federal service. My three children are products of Richmond schools, and our family loves experiencing the city's arts and restaurants scene, kayaking in the James River and rooting for the Flying Squirrels. For the past thirty-three years, I have been proud to declare, "Richmond is my hometown."

Trammell and Terrell have marvelously captured the richness and depth of my hometown's 400-year history in a mere one hundred or so pages. There are the origin stories of Richmond that even longtime residents may not know: the Algonquian people who originally lived here; the 175 years Richmond spent as a part of Henrico County; and the reluctance of Richmond's founder, William Byrd II, to even let the settlement become a city. Among this book's accounts of the Revolution, the antebellum period and the Civil War are fascinating stories: how the original seven hills were flattened; Richmond's position as "an American bread basket" exporting 242,916 barrels of flour in 1 year alone; and the trial and hanging of three Spanish pirates in 1827. The final chapters give due attention to the past century: the impact of twentieth-century events like the Great Depression and World War II; how Jim Crow and white flight have shaped the socioeconomic fabric of the city today; what civil rights heroes did to help free the city from the bonds of racism; and the emergence and growth of cultural institutions that liven the city to this day. The authors leave virtually no chapter of our history unexplored.

However, Trammell and Terrell's great achievement is not merely compiling four centuries of anecdotes and statistics in one convenient reference place, but that they do so in a way that impresses on the reader just how complex and diverse this city is. One comes away from this book understanding that there is no typical Richmonder. There are the Algonquian residents of Parahunt's village and the English explorers who clashed with these first people; colonial tobacco tycoons like Thomas Stegg and recent corporate leaders like the Gottwald family; slave rebel Gabriel Prosser and Confederate president Jefferson Davis; poets like Edgar Allan Poe and musicians like Edgar Schenkman; the city council members who imposed Jim Crow laws and John Mitchell Jr., who lambasted their injustices in the *Richmond Planet*.

Richmond is all of these contradictory characters. It's all of the tales—famous or overlooked—preserved within these pages. It's the strangers whose welcoming nature first made me fall in love with this city; the citizens who have taught me everything I know about public service; and the thousands of neighbors whom, thirty-three years on, I still brag about wherever I go.

I want to conclude with two notes of gratitude. To the authors: Thank you for beautifully capturing our multifaceted city. To the reader: Thank you for taking such an interest in my hometown. If you have lived in Richmond for a while, I hope you'll enjoy learning more about our city as I have. If you are reading this book having only recently arrived here or having never set foot here, I feel the same way toward you as Sheriff Andy felt toward Ed Sawyer; out of all the towns you could learn about, you chose to take an interest in Richmond. That makes this Richmonder feel pretty proud.

Senator Tim Kaine

ACKNOWLEDGEMENTS

A project like this one can never be completed without a great deal of collegial help, as well as the support of friends and family. We would specifically like to mention a few of the many individuals and institutions who played a key role: Randolph-Macon College and the library staff; Professor Michael Fischbach; the staff of the Library of Virginia; the Library of Congress; our acquisitions editor, Kate, and the staff at Arcadia Publishing/The History Press; the Valentine Museum; the Virginia Historical Society; the Virginia Foundation for the Humanities; the National Park Service and Civil War Center at Tredegar; Grace Tabernacle Church in Richmond; Virginia Commonwealth University and the Wilder School; the University of Richmond; the Richmond Tour Guys; the Richmond Public Library; Misti Nolen for her photos; Kimberly Hise Photography; and Kelly Justice for the idea.

INTRODUCTION

Richmond is a delightful city in which to live, to raise a family or to start a business, as well as to visit. But to everyone who touches it, they should know that it is a city with a past, present and future that are complicated and sometimes difficult.

Many of us who live near or in Richmond love the city, but nearly everyone also understands that time has made Richmond into something that no other city can be. This book is a small attempt to tell the reader what that something is and why it is important.

Books are always a labor of love, and this one is no different. If you don't come away from this book wanting to visit, live or work in Richmond, or at a minimum appreciate it from a distance, then we will have failed in our purpose. We hope that everyone will find something in Richmond's story that inspires, something that gives you cause for deeper reflection and something that gives hope for an American future.

We wish you happy reading and hanging out in Richmond!

Jack Trammell
Summer 2017

This book will explore many aspects of the city's history but cannot cover them all. It will lay out how Richmond's history impacted its culture, its traditions and its appearance. Today it has many fine restaurants, galleries, art and music festivals, numerous museums, historic

buildings and cultural events—many of which are free or at low cost. There are also sporting events, symphonies, operas and theater performances, both professional and amateur. Additionally, the city has always had a strong religious heritage. Its history helps explain this rich and deep heritage with many new opportunities for an equally rich future.

Because much of Richmond burned during the evacuation of Confederate troops in April 1865, a large portion of the city was rebuilt near earlier structures. Since Richmond never experienced the extreme growth of some other cities, many older downtown structures have been repurposed rather than torn down. The arrangement and position of the city's streets, roads and buildings reflect decisions made by city administrations and other builders over a period of four hundred years. The history of this city is like a pop-up storybook in which the streets and buildings reflect the input of each inhabitant's efforts and aspirations. We build or rebuild our city with our thoughts, hopes and dreams each day.

Geological history cut what would become the city in half. Coal could be found near the surface, and granite outcroppings were exposed along the river. Both materials were fundamental to the city's development. Richmond's location made it a natural transportation hub for much of its history; today, it benefits economically from being part of the "Golden Crescent" formed by Washington, Richmond and Norfolk.

As you will learn in the following pages, many institutions and major buildings were the result of private initiatives and of efforts of the federal government. Historically, local jurisdictions have focused on narrow objectives or have been hamstrung by the conservative nature of its citizens. On the brighter side, the story of the major achievements that took place over the course of time in Richmond occurred because of the connections among people with similar goals, such as the original city public library. For most of its modern history, a few people who knew each other through their churches, neighborhoods or other affiliations would band together with a goal or target such as a public library, symphony or botanical garden. They would recruit others, form a league and find a powerful or well-connected person to become the leader of their effort. Usually, there would be petitions to city council, and these would be turned down. Eventually, they achieved their goals through consistent effort or a fortunate turn of events. This model worked for the efforts of both the African-American and white populations. Today, we simply call it networking.

When Richmond was smaller, networks and social groups were smaller. Also, newspapers, the primary common medium, reported on the progress

of initiatives and served to bind the entire metropolitan area together. There are many examples of how institutions formed throughout this book. Today, it may be more of a challenge to foster new initiatives, since those with similar goals live in different jurisdictions and there are fewer civic leaders of the stature of those who formerly resided in the city. Those with similar goals have a harder time connecting with each other despite social media. We connect through institutions with specific goals, such as the American Civil Liberties Union, Equality Virginia, the United Way and through any of several religious organizations. We have fewer common goals than in the past.

Libby Germer, a teacher at George Wythe High School, summed up the essence of Richmond in an article she wrote on the Yale National Initiative website:

> *Richmond, Virginia, is full of contentious and uncomfortable histories. The city is a former capital of the Confederacy, a port where native Powhatan Indians were once displaced by English settlers, a place where African slaves were shackled and auctioned off in downtown markets, and the home of massive resistance to school desegregation in the late-1950s which forced the federal government to directly intervene. Competing narratives of public history show up in racial and socio-economic tension over seemingly innocuous school zoning changes or during regional elections. I believe that these conflicts are exacerbated and perpetuated by a great disparity in the living conditions of city residents; because these arguments are deeply rooted in historical injustice, they continue to bear bitter fruit. One such fruit is modern de facto housing segregation, where the racial divide is particularly clear.*

Richmond bears all the scars and the beauty of its history. It continues to face challenges that call for inspired solutions and approaches. We are but the current tenants of a place where many have lived before and many will come after us.

There are many well-documented, specialized books on the history of Richmond. We intend this book for the general reader, hence no footnotes. The bibliographic essay at the end of the book will list sources for further reading. There is much to explore beyond these pages. Our goal is to provide a reasonable overview of what took place in the making of this unique city.

Guy Terrell
Summer 2017

"I Hear Richmond Singing"
(after Walt Whitman)

I hear Richmond singing, varied and long, I hear,
The baristas, blithe and strong, up since pre-dawn, call out your order,
The judge in her black robe singing the song of the law from the bench,
The newscasters singing sunrise and sunset beside random acts of nature,
The drivers singing at stoplights before loading and unloading their boxes
 and crates,
The machine tenders singing as they cross factory floors tending their work,
The bankers humming to the sound of debits and credits,
The monument sweepers singing over the lawns and leaves that rustle in
 response,
The mothers and fathers singing children off to school, to sports or music
 lessons,
The young women singing in the dress shops and shoe stores,
The young men singing the songs of bulldozers moving earth and gravel,
I hear train horns when they cross streets and span the James River,
I hear ambulances as they flash and firetrucks singing out flames,
I hear fans cheering the Squirrels and Kickers, the Richmond International
 Speedway,
I hear each one singing their song on the bus, down the street, over the
 school
When the whole city wakes day after day singing its diverse and robust tunes.

1

NATIVE AMERICANS AND HUMANS ON THE HILLS

We laid the foundations of two large Citys. One at Shacco's, to be called
Richmond, and the other at the point of Appamattux River to be named
Petersburgh....The Truth of it is, these two places being the uppermost landing
of James and Appamattux Rivers, are naturally intended for Marts, where the
Traffick of the Outer Inhabitants must Center. Thus we did not build Castles
only, but also Citys in the Air.
—William Byrd II, 1733

The present city of Richmond sits atop land that has been inhabited and utilized by humans for many thousands of years. The geography and climate perhaps made this inevitable. Richmond rests on the Fall Line, the geological and geographical division between the hilly, weathered bedrock of the Piedmont region and the flatter, marshier plains of the Tidewater region, a division that runs north–south roughly along the current route of U.S. Interstate 95. At the Fall Line, the James River becomes unnavigable due to several miles of ledges, rapids, sharp drops and torrents. The exposed granite would later be used to build impressive structures, including official buildings in Washington, D.C., and Richmond. To earlier dwellers, however, the hills on the northern bank of the river simply offered shelter from flooding, easy access to fresh water and transportation, a defensible position and a convenient gathering place.

Early Native Americans, mostly members of the Algonquian tribes (including those near the future city of Richmond—Arrohattoc, Appomattoc, Mattaponi, Pamunkey, Powhatan and Youghtanund), utilized the area as

a transient camp for convalescents and as a village during certain lengthy periods. The presence of fresh water and river resources, the high ground and a central location served as an effective gathering point for women, as well as sick or wounded warriors, while men were out on warm-weather forays. Later, when the first European explorers and colonists arrived, they immediately noticed the same characteristics of the area and were attracted to it, despite the presence of established Native American villages.

Only a week and a half after landing at Jamestown in 1607, Captain John Smith and Christopher Newport noted Parahunt's (Powhatan's son, a *werowance*, or subservient chief) town at "the Fales" on a foray up the James River. They claimed it for the English Crown, placing a crude cross inscribed "Jacobus Rex, 1607" on a nearby island. (The village and islands were near the present location of Gambles Hill, below the falls.) Travelers today can follow Smith's historic route by bike, car or foot.

Like famous Rome, the land of Parahunt's village and surrounding cornfields (and John Smith's vision of a future settlement) was composed of seven hills, hence Richmond is still sometimes known as the "City of Seven Hills." (Roanoke, Virginia, also claims this name.) Just over a year after the founding at Jamestown, another exploration of the modern site

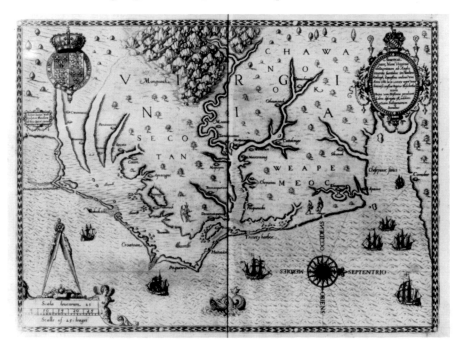

Map of the coast of Virginia in 1585. *Library of Congress.*

of Richmond was sent out by Christopher Newport. The 1608 mission returned hungry and unsuccessful. In 1609, John Smith organized yet another expedition under Captain Francis West, this time with more than one hundred men and food for six months. This attempt, too, failed for a variety of reasons (including a rebellion against Smith), and Little Powhatan's Village below the falls remained the only settlement near present-day Richmond for the time being.

Another doomed expedition returned in 1610 to establish a fort and surrounding cornfields on an island just below the falls. Tasked to search the area for minerals, the small party at the fort was lured into a trap by Native Americans and slaughtered except for one man, who escaped to tell the story. To this point, English attempts to settle on present-day Richmond had all failed. It seemed at first that European attempts to settle the area were doomed to failure.

In 1634, the council and general court divided the new colony into eight shires, including Henrico, where Richmond would later be established. But it would not be until 1645 that the legislature would direct attention back to the seven hills with orders to build Fort Charles there to protect settlers moving westward. Although construction started on the north bank, where Richmond would ultimately be sited, the fort was quickly moved to the south side of the river, where sporadic settlement and cultivation had already proceeded more rapidly. Once again, the north side of the river remained for some decades the home to Native Americans and wildlife—and sporadic trading—while the south side expanded.

Henrico Shire (later Henrico County) originally extended westward almost several hundred miles both north and south of the James River. Later in 1728, Goochland County was carved away to the west; in 1749, Chesterfield County was established from Henrico lands to the south. For the better part of almost 175 years, the area and town that became the city of Richmond was part of Henrico County until it was officially incorporated as a city in 1782.

The City Begins to Rise

The early problems and settlement on the river's south bank didn't mean that activity didn't start in the area of the seven hills very soon after the founding at Jamestown, or that settlers did not come through fairly routinely.

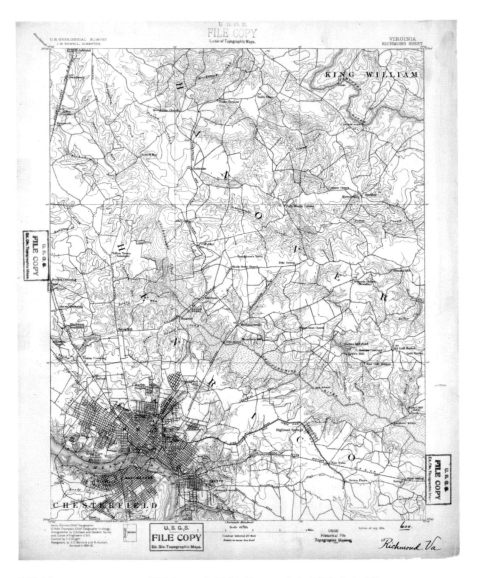

Official government map of Richmond, 1894. *Courtesy of the US Geological Survey.*

In 1656, a battle was fought at what today is a stream called "Bloody Run" (near Marshall and Thirty-First Streets) between allied English forces with Colonel Edward Hill and natives from outside the region seeking expansion space. Severely defeated and at great human cost, the settlers and their native allies (including many Pamunkey tribe members) had to sue for peace, and Hill was severely censored by his own legislature for his actions.

Settlement continued mainly to the south of the river, where Thomas Stegg Jr. and others purchased large tracts of land to establish tobacco plantations. Later, William Byrd I lived in Stegg's stone house and established a trading post at the falls on the James River. He increasingly owned properties throughout the area that would become Richmond on both sides of the river. Nathaniel Bacon, soon to be famous (or infamous, from the Royalist perspective) for Bacon's Rebellion (1676), owned land and a trading post adjacent to Byrd in the area now west of Brook Avenue as it fell toward Shockoe Creek. ("Shockoe" comes from "Shacquohocan," from the Powhatan tribe's word for the large, flat stones at the mouth of Shockoe Creek, also from a 1663 map calling it Shaccoe Creek. The word *slip*, picked up later, refers to the area's position on the canal basin where boats loaded cargo.) Still, at this time, there was no permanent town at the site of Richmond, and most of Byrd's warehouses and businesses were south of the river.

In fact, Byrd's son William Byrd II, who is usually credited with the "founding" of Richmond, actively resisted turning the less developed north bank into a settlement at first. Although he owned land ranging from what would be the city of Petersburg to what would be Powhatan County and significant tracts north of the river totaling thousands of acres—an economic empire built on enslaved peoples and tobacco— as late as 1727, he resisted selling the north bank land to the House of Burgesses for the establishment of a town. Later in 1733, when he realized that, due to the new growth of settlement on the north side, a town on the seven hills was inevitable whether he wished it or not, he penned his famous lines, as quoted by Virginius Dabney, about "Citys in the Air" and laying "the foundations of two large Citys. One at Shacco's, to be called Richmond, and the other at the point of Appamattux River to be named Petersburgh." The area around the falls reminded Byrd of Richmond on the Thames, where he had spent significant portions of his life back in England.

When Major William Mayo formally staked out the outlines of the town in 1737, it was already a settlement, with taverns, tobacco traders, stores, dwellings and churches scattered in the immediate area, as well as a ferry that Byrd had built to allow his businesses to cross the river freely. Just as in the distant past, human traffic and economic exchange had gathered on Richmond's site naturally without a town being formally declared, despite Byrd's early objections. The site and noise at the falls and rapids seemed to draw people as well, causing a sarcastic Byrd to state that they "murmur

loud enough to drown a scolding wife," wrote Virginius Dabney, author of *Richmond: The Story of a City*.

Mayo surveyed neat lots along the river in the area roughly below today's Church Hill, and these were widely advertised for sale. (Byrd sent a recruiter to Philadelphia to attract German settlers.) Founders even thought to reserve several larger parcels of land to the west for eventual expansion, perhaps one of the earliest examples of American urban planning. The General Assembly formally acted (after some delay) to charter Richmond as a town in 1742, legislating that the town should hold two fairs a year to facilitate commerce. It would be formally incorporated as a city much later, in 1782. (Although, as it grew, it had begun to function more like a city before then.)

The first church constructed in the new town was the "Old Church," built on the appropriately named Church Hill and completed in 1741. It was later to be famous as St. John's Episcopal Church, where Patrick Henry declared, "Give me liberty or give me death!" Early Richmond was home to a variety of construction techniques, many of which used native timber and brick or stone, and many that reflected architectural styles of both England and the rough immediacies of the New World. The danger of fire quickly led to a 1744 town requirement that all chimneys be made from brick. Other early notable structures surviving into the present include: the Mason's Hall (1785, oldest in the United States); Patteson-Schutte House (circa 1750s, oldest frame structure in the city); Woodward House (circa 1784, last surviving building of Rocketts Landing); and Old Stone House, now known as the "Poe House," although Edgar Allan Poe never lived there (circa 1754 by one dating, 1783 by formal written records).

The home for the local Freemasons is of particular note. In fact, the Richmond area was one of the earliest regions in the New World to host Freemason activity, as early as the 1750s. During the French and Indian War, a British officer supposedly founded the first "lodge" in the Richmond environs. The Grand Lodge of Virginia was formally founded in 1778, and Richmond No. 13, now called Richmond No. 10, was the first lodge established officially, in 1780. Famous members have included Solomon Jacobs, William Foushee, John Marshall, Edmund Randolph and William Gault. Although Masonic history is often shrouded in mystery, there is little doubt that Freemasonry in the United States has many important ties—even to this day—to its original Richmond roots.

The growth of stage lines and other interior roads also benefited the inhabitants of Richmond. Situated as it was on the Fall Line, the town was a logical intersection for north–south turnpikes, such as what would

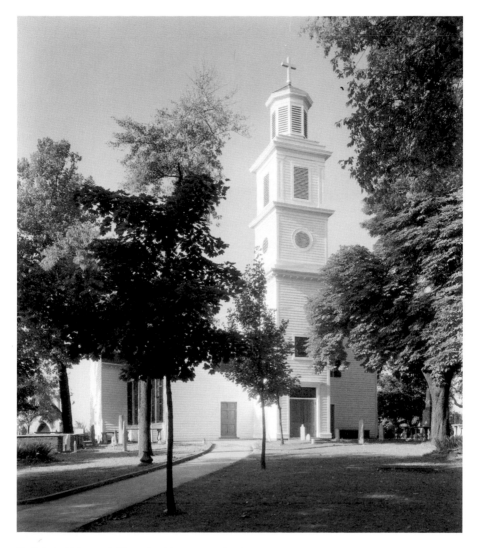

St. John's Episcopal Church, oldest church in the city and site of Patrick Henry's speech. *Library of Congress.*

become the Main Post Road, in the Confederation Period and east–west routes, like the Old Mountain Road—Powhatan's other road to the mountains, which quickly became a main route leading west of the city. (The better-known road was "Three Notch Road," or what would become Three Chopt Road.) Roads were generally unimproved, meaning that they were essentially mud tracks through the woods and country. Upkeep and improvement of roads consumed much energy and political capital during

the Henrico County phase of administration and, later, when Richmond was officially an incorporated city. Landowners were normally responsible for the upkeep of roads that traversed or paralleled their properties. There were chronic complaints about those who didn't fulfill their duties or were asking for money for work that was only adequately completed or not done at all. Increasing commerce in the town of Richmond and environs led to calls to improve the navigation of the James River, and the assembly passed a law in 1745 facilitating cleaning and clearing of the river. (The actual work never really was completed effectually, only in fits and starts.) Later, bills were passed to build a canal around the falls. The American Revolution would eventually bring these improvement efforts to a halt. Nevertheless, the economy in Richmond continued to grow, and connections were expanded through coach routes north and south into the Carolinas, along with boat traffic out through the bay up to Baltimore and other northern cities. Ships came directly up the James to places like Manchester, a port town directly across the river from Richmond that was incorporated in 1769 and would much later be part of the city, or to Rocketts Landing on the north side.

The Commerce of Tobacco

A large part of the economic growth of Richmond, as well as of Virginia, was a direct result of tobacco. The "leaf," as it was called, was a financial boon from the earliest days of the colony. Because the agricultural growth had spread faster south of the river, most of the warehouses were also situated there. This would later lead to conflict over controlling the commerce as the towns of Manchester and Richmond struggled to control the revenue (although Richmond would eventually win this contest). Mayo's Bridge, built in the 1790s, was an important connection between the two places. Tobacco functioned as a de facto currency, with court cases and fines being levied in parts or numbers of hogsheads of tobacco. (Hogsheads were large wooden barrels used to roll tobacco to market, hence many roads were referred to as "rolling roads.") Tobacco was constantly shipped out, and goods from all over the world routinely came in to Richmond, Rocketts and Manchester. Much later, Richmond would manufacture brands of famous tobacco companies such as Philip Morris and American Tobacco.

The exhaustion of the soil in the lower Tidewater area forced tobacco farmers and plantations increasingly westward, well above the Fall Line

where oceangoing ships could not reach them, into areas where forest had to be cleared and new soil exploited. Getting this tobacco to market proved a formidable challenge. Native-style canoes (dugouts) could navigate the river easily, but they carried very limited payloads. Rolling the tobacco from the west was difficult and negatively impacted the ultimate quality of the product. One enterprising trader created a pontoon-like boat with two canoes, and this worked moderately well. Ultimately, the invention of the bateau, a flatboat ideally suited to the James River, by an enterprising western planter named Anthony Rucker would solve many of the issues and fuel further commerce in Richmond. In 1767, the assembly collaborated by again passing legislation to clear the river and create additional navigation aids, many of which can still be found in the modern environment of the river (sluices, artificial channels, etc.).

The French and Indian War came at a time when Richmond was growing quickly, but larger forces overshadowed regional growth and prosperity. As early as 1613, Virginia settlers had sailed from Jamestown all the way to Mount Desert Island (in present-day Maine) to destroy a French outpost. In 1754, open warfare between England and France broke out, with Virginians and Richmonders supporting the British Crown and various Native American tribes taking one side or the other (or trying to stay completely out of the way). Although all of the major campaigning took place far to the north of Richmond, mainly in the western areas of the Ohio River Valley, many men from the Richmond area fought as militia or otherwise served until the Treaty of Paris was signed in 1763. Many Virginians who later played prominent roles in the American Revolution, such as George Washington, served in this conflict.

THE PRE-CITY

By 1769, the population of Richmond had more than doubled to nearly six hundred inhabitants in the town proper. Newspapers like the *Virginia Gazette* were well established before the Revolutionary War. Entertainment in early Richmond was notably crude, consisting mainly of gambling, drinking, horse racing and horse trading, plus wrestling matches. According to Richmond historian Virginius Dabney, one young woman who was forced to move to Richmond with her family during the Revolutionary War declared with evident disgust that even by this time Richmond had "scarce one comfort

of life." In the late colonial period, the town was rough, muddy, under construction and busy.

Richmond was subject to terrible flooding every decade or so. True to most river cities in human history, the status of the resident increased with every notable increase in elevation; these were the homes and business that were more insulated from floodwaters. Flooding of the James in severe years like 1667 had shown the dangers of building close to the water (even John Smith had argued with Francis West about establishing his first outpost too low upon the embankment), and the businesses and less fortunate residences close to the water were subject to great destruction whenever the waters of the James periodically encroached. In a record 1771 flood, a huge, living wall of water that stunned eyewitnesses moved so quickly through the lower city that people could scarcely react in time to get out of the way. Entire warehouses were washed out to sea, and as many as 150 people were killed. The Randolphs of Turkey Island just below Richmond erected a nearly twenty-foot-high obelisk to indicate where the violent floodwaters had peaked. The unpredictable James would remain a constant wild card in the city's long and diverse history.

REVOLUTIONARY RICHMOND

Despite disasters, war and periodic economic downturns, the town of Richmond continued to grow and flourish throughout the colonial period. Before long, Richmond exceeded Williamsburg in economic and geographic importance and competed with other burgeoning Virginia cities like Alexandria, Norfolk, Petersburg and Fredericksburg. Periodically, the town of Richmond annexed small areas of Henrico County and grew in geographic size as well as in population and scope of commerce. Although Henrico County, and the town of Richmond within it, supplied their share of men and resources during the French and Indian War, it was only with the coming of the American Revolution that Richmond's date with American destiny began to fully become manifest. Richmonders and their Henrico neighbors were well aware of the growing tensions with the mother country, even before the mid-1760s, when Patrick Henry brashly attacked the Stamp Act at the capitol in Williamsburg, for example. Although connected to the outside world, Richmond had developed with a westward-gazing, independent, frontier-oriented mind-set that did not naturally turn around toward Great Britain. After larger events moved the colonies toward the first

Continental Congress, Richmond began to assume much greater political importance on the national and international stages.

As unrest rippled through Virginia and relations with Great Britain grew further strained, a group of prominent Virginians organized a state convention in early 1775 that would meet in Richmond, still more a busy town than a true metropolitan or political center but farther away from Williamsburg and British authorities near the coast who had naval resources. The meeting was held at St. John's Church atop Church Hill on March 20. A few days into the convention, Patrick Henry introduced a resolution for "a well-regulated militia" and then shortly thereafter filled the gallery with his famous "Give me liberty or give me death!" oratory that changed American history. Richmond was about to go to war, this time for American independence.

Tourists and history buffs today can visit St. John's, which remains an active Episcopal church and has been declared a National Historic Landmark. There are artifacts and other visuals on permanent display, as well as reenactments re-creating famous moments from the second convention and other important events. The cemetery was the first public burial ground in Richmond proper and is the final resting place of Edgar Allan Poe's mother and of George Wythe, signer of the Declaration of Independence, among others of note.

Richmond was destined to play an even larger role in the coming conflict. Other conventions met, young men drilled in local militias, potential war-related businesses geared up for military production and a general air of excitement was sustained and extended into the next year. In nearby Westham, a foundry produced cannons and cannonballs. From areas west, such as Staunton, local militias acquired gunpowder shipped on flatboats down the river. Enslaved people sometimes worked overtime (their masters generally received the extra income) to keep up with the demand for military items.

In May 1776, the Fifth Virginia Convention in Williamsburg declared Virginia a free and independent state. In June, many Richmonders celebrated the news that the same group in Williamsburg had written a new state constitution and elected Patrick Henry the first independent governor of Virginia. A short while later, they celebrated again when the Declaration of Independence for the new republic of the United States was adopted in Philadelphia on July 4, spurred in large part by the delegates from Virginia, who were instructed to push hard for its approval. Events seemed to be spiraling quickly. Richmond later would

be in the center of a much less celebratory event when the British attacked the area.

Dating back to a time prior to the formal incorporation as a town by the assembly in 1742, rumors about moving the capital from Williamsburg to Richmond had become so routine as to be part of regular central Virginia gossip. In 1779, however, the circumstances were significantly different. The young nation was at war with a powerful naval adversary that could dominate coastal areas, and Williamsburg, situated near the open lower river, was vulnerable. In fact, important records had already been moved to Richmond for safekeeping. In addition, Richmond's central location in the colony and in the developing transportation network made it ideal to coordinate wider war efforts in the region. The act to move the state capital to Richmond was passed by the assembly in 1779, and the actual move took place in 1780. The act also required that the town furnish six squares for situating new public buildings, including a meeting place for the assembly. There, the Fall Line would prevent the British navy from moving farther inland via water, presumably giving the colonists more warning of a British invasion of western Virginia. As it turned out, the British would soon come without warning to Richmond and nearly capture Governor Thomas Jefferson, second Governor of Virginia, and other officials.

BRIEF HISTORY OF THE GENERAL ASSEMBLY

Today, the legislature for Virginia still meets in Richmond and is referred to formally as the General Assembly. In its long history, however, it has been known by different names and has met in different locations. Here is a short timeline.

> 1619 *House of Burgesses (Jamestown), the "Oldest continuous law-making body in the New World," meets in a church on Jamestown Island. (Technically, the "General Assembly" consisted of the House of the Burgesses, the Royal Governor and his council; members of the house were elected by their towns.)*
>
> c. 1650 *The assembly is sometimes referred to as the "Grand Assembly of Virginia."*
>
> 1699 *The capital of the colony and the assembly move to Middle Plantation (Williamsburg).*

1776 *A new Virginia constitution establishes a bicameral General Assembly with a senate and house of delegates. (A historic last meeting of the House of Burgesses occurred in May of the same year.)*

1780 *During the governorship of Thomas Jefferson, the capital and assembly move to Richmond.*

1830 *First of six major revisions to the constitution (later 1851, 1864, 1870, 1902 and through a commission in 1971), this one reduced the number of delegates and senators in the assembly.*

1971 *Current constitution governing the assembly and state government in Virginia, consisting of twelve articles, is established.*

In the text, the authors sometimes generally refer to the Virginia legislature as the "assembly" to avoid confusion, especially in the earlier parts of Virginia's history.

Another nickname for the city—the "city of lawyers"—came about at this time, due to the large number of lawyers migrating from Williamsburg to practice in the new capital in Richmond. Edmund Randolph was one of them. Among many other things, he would serve in the fledgling new national republic as attorney general. Edward S. Corwin, according to Virginius Dabney, "termed the Richmond bar the most brilliant in America at the period."

Richmond found itself the new state capital in a rebellion against a powerful mother country. Although the early war did not touch the area directly except for the Battle at Great Bridge in Norfolk, in the later stages of the war, the battleground would come directly to the seven hills. The most famous "skirmish" in Richmond took place on January 5, 1781. Benedict Arnold, first an American hero and then a traitor to the American cause, now commanded British forces, including the Queen's Rangers and regular British army units, which faced "rebel infantry" (some locals said that they appeared more like disorganized volunteers from the area than infantry) on the northeast side of the city. Governor Thomas Jefferson was forced to flee as Arnold proceeded to enter the city and burn large portions of it, including a number of warehouses that contained important stores and war materiel. He moved west toward Westham, where American forces under Baron von Steuben waited for him. Arnold's men burned more property at the foundry where, ironically, Jefferson had taken important materiel and records for safekeeping. Then he returned to Richmond to complete his work of destruction. It was not Jefferson's or Richmond's finest hour.

Richmond also played a role in the decisive Battle of Yorktown that ended the war and guaranteed American independence. Benedict

Arnold's men in Virginia were joined by Major General William Phillips and his army. Combined, these forces took Petersburg on April 25, 1781. According to the National Park Service (NPS), "Phillips then moved towards Richmond, but by then Lafayette had his troops there and thwarted the British attempts to take Virginia's capital." Shortly thereafter, Lord Cornwallis arrived from the Carolinas with another army. Richmond, had the British wanted to take it again, would have been vulnerable. "I am not strong enough even to get beaten," Lafayette wrote to Washington at one point. Instead, Lafayette and Cornwallis shadowboxed until the British ended up in Yorktown, hoping to meet their fleet at the river. The American and French forces laid siege to Yorktown, and the French fleet arrived to block outside help from reaching the British. On October 19, 1781, Cornwallis surrendered, ensuring American independence. The celebration in Richmond, and across the country, began shortly thereafter.

Many Richmonders and central Virginians participated directly in the war for independence. Under such men as Daniel Morgan, Virginia sent militia north to join the Continental army forces and to the frontier northwest to fight. Virginia soldiers like Dennis Trammell volunteered for service and ended up fighting all over the South, including the key battle at Cowpens. The soldiers included volunteers of color. Charles Lewis and his brother Ambrose, free blacks born in nearby Spotsylvania County, served in both the Navy of Virginia and the U.S. Navy, and then later with the Virginia militia infantry in South Carolina. Charles later married, raised a family and ran a business as a barber in Richmond until his death in 1833. He also "owned a warehouse at Rocketts Landing," according to blackpast.org, indicating a significant level of prosperity.

In 1782, Richmond also established its own more formalized internal governance, holding an election on July 2, 1782, to elect twelve propertied representatives for the city. From among the twelve men, William Foushee was selected to be Richmond's first mayor; six others were selected to form the first council, which would meet in the "Common Hall." Among the early orders of business were the sale of city land to fund the construction of public buildings and an act from the assembly requiring the city councilmen to oversee "important improvements…to the streets, lanes and alleys in the city." If Richmond were to grow, the infrastructure to support it would need to be improved. This would remain a constant theme in Richmond's history, later involving railroads and highways.

THE COLONIAL CAPITAL

Life for the average Richmonder, outside of Arnold's raid and the war in general, remained a relatively day-to-day and ordinary experience. Women commonly did their laundry in Shockoe Creek and shared news, and they dried it along the nearby grassy hill; the adjacent market was a "shed supported by locust posts." The city streets were muddy and impassable after a hard rain, and practically all of the private homes were still constructed of simple frame designs and crude materials. There were some small schools, but children by and large roamed freely and chased dogs and cats throughout the town when they weren't working or with their parents. A small but important free black population was also permanently established by this time and would remain critical to the success and character of the city. Enslaved peoples were increasingly evident, both at work for their owners and being bought and sold in Richmond itself. The Richmond slave trade was connected to a burgeoning international market that Richmond would play a central economic and political role in.

The town benefited from the continual arrival of immigrants, many from Scotland, Germany and Ireland. Many can be found in the regular city directories published in the post-independence, antebellum period. Most brought with them a trade, ranging from brewmasters and bakers to silversmiths and jewelers. Barrel makers collaborated with a burgeoning flour mill industry. These immigrants established communities and traditions that are still in evidence in Richmond. Meanwhile, Richmond was growing in prominence even as American independence became a reality. In 1788, representatives from all over Virginia gathered in the city to debate ratification of the newly written U.S. Constitution. They would play a pivotal role in the national debate. Without Virginia's delegates' support, which included such prominent figures as John Marshall and Edmund Randolph, the adoption of the political framework for the new country would have been in jeopardy. After vigorous debate, the national ratification passed by a relatively close ten votes (eighty-nine to seventy-nine), and Richmond once again was a significant part of the great American experiment.

Richmond actively become involved in the new government in practical ways, as well. According to James K. Sanford, the first U.S. court convened in Virginia was held in Richmond, with the Honorable Cyrus Griffin on the bench. The year was 1789, and many prominent federal cases were heard in Richmond's district court, which serves in a different format into the present time.

In 1793, the stone bridge across Shockoe Creek called for by the assembly as part of the infrastructure improvement was completed, replacing an inferior wooden structure and allowing heavier traffic up to the city from the landing at Rocketts. Flatboat and wagon commerce continued to grow from the west, as well. The types and diversity of businesses are evidence of this. Thirsty Richmonders, for example, had to drink, and Hay and Forrester began making a well-known Richmond beer at Northeast Canal and Fourth Streets, creating a business that came to be known as the "Richmond Brewery." By 1804, Alexander Plainville operated one of the largest distilleries in the city at Main and Fifteenth Streets.

The economic growth was also evidenced by the appearance of larger homes and mansions in the area. John Marshall arrived in Richmond in 1782 and was later named a U.S. Supreme Court justice. He was involved in many of the famous court cases that determined the young nation's future, including *Marbury vs. Madison*. The John Marshall House (circa 1790) at 818 East Marshall Street in the famous Court End neighborhood can still be seen by visitors today. Marshall is often called "the greatest man to never be president." His neighbor was another famous Richmond attorney, John Wickham, who defended Aaron Burr. Joseph Ege, a German immigrant, built the Old Stone House (circa 1740–50), today home to the Edgar Allan Poe Museum. Just east of Richmond, the Wilton House, a brick plantation mansion built in the Georgian Manor style, was constructed around 1753 for William Randolph III and his wife. When it fell into danger of being lost, the National Society of the Colonial Dames of America succeeded in having the home relocated to Richmond in 1934 (215 South Wilton Road), where it can still be visited.

According to Dabney, John Mayo Jr. used the wealth from his toll bridge to build a home, the Hermitage (later the site of Broad Street Station), and a second home at Bellville (West Grace Street). Thomas Rutherford built a brick home in the west end (Franklin and Adams). There were many others, most of which have not survived into the present.

This was an exciting period of change and growth. From 1607 to 1783, Richmond was transformed from a quiet series of hills above the rapids of the James River into a prominent and prosperous capital city of an experimental democratic state in a brand-new nation. Streets and roads were moving westward; brick and larger permanent buildings were going up; boat and wagon traffic was buzzing. A canal around the falls prompted by General George Washington in 1784 would continue to be built. A new capitol building of classic Greek design—drawn up

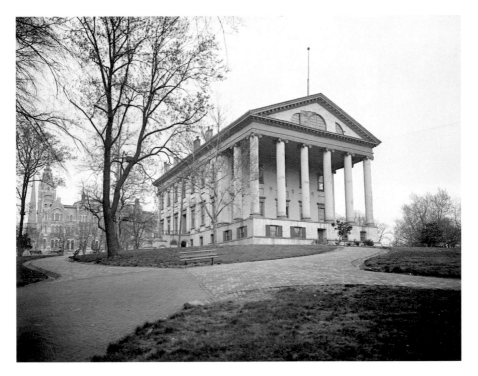

Capitol building, Capitol Square. Photo by William Henry Jackson (1843–1943), circa 1901. *Library of Congress.*

by Thomas Jefferson and Charles-Louis Clérisseau of France—would be completed in 1788 and become a signature landmark of the new republic. Mayo's Toll Bridge was completed in 1788. The city was home to patriots and pioneers, and its colorful history had only just begun.

RICHMOND BETWEEN THE WARS

There is no beauty without a little strangeness.
—Edgar Allan Poe

Richmond, between the Revolutionary War and the outbreak of hostilities at the start of the American Civil War in 1861, was a classic example of a growing antebellum southern city, second only to New Orleans in commercial importance and to Charleston in terms of the Atlantic Ocean international trade. As many as five railroads would ultimately converge in the area; the James River and Kanawha Canal were busy with flatboat traffic (construction westward would stop at Buchanan in 1851); all roads in central Virginia led to Richmond; and all but one of the major regional turnpikes ran north–south through Richmond. To get anywhere in the Southeast by land from anywhere north of Virginia required going through Richmond. Moving to Richmond in growing numbers were financial services; the still-booming tobacco and cotton businesses; and heavy industries, including foundries and mills.

One observer between the wars described Richmond as a series of jumbled ups and downs across variations in the terrain. Over the years, many projects were undertaken that leveled the terrain and flattened parts of some hills, so much so that the contemporary visitor will likely have some difficulty imagining what the original inhabitants must have seen. Initially, Richmonders settled on the seven hills, eventually known as Church, Union, Navy, Gambles, City Council, French Garden and Shockoe. Later, the area

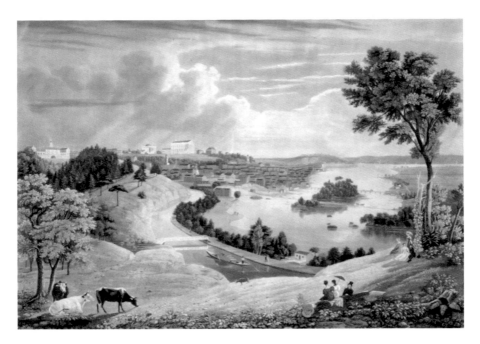

Richmond, view of the canal and city as it appeared in an 1834 painting. *Library of Congress.*

named Oregon Hill near Hollywood Cemetery became an established western neighborhood dramatically perched above the river. As the population grew in the antebellum period, all the spaces between the hills— and even some parts of the hills themselves —began to fill in. However, the most expensive and exclusive neighborhoods have tended to be those on higher ground, protected from the sometimes-violent waters of the James.

COMMERCIAL ACTIVITIES, INCLUDING SLAVE TRADING

On a more somber note, the dozens of slave auction houses and banks with overseas and northern connections also meant that the Richmond slave-trading network and its host of supporting businesses (shippers, doctors, tailors, bankers and agents) was the economic and political backbone of the entire American domestic slave trade (although greater numbers of slaves and more dollars actually changed hands in New Orleans). New Orleans was, like Richmond, ideally situated on major transportation networks, including

the Mississippi River, to supply slaves in the new southern territories pushing westward. It became a much larger city than Richmond. Nevertheless, Richmond remained connected to all regional markets and to the political and financial capital of the nation in significantly different ways from that associated with New Orleans.

The area of Richmond that housed most of the slave-trading businesses was located on or around Wall Street (between Fourteenth and Fifteenth Streets), so-named for the crude retaining wall that held the earthen banks intact above Shockoe Creek. By the antebellum era, this rough neighborhood was an area not frequented by "polite company," and many of those with stakes in the trade used seconds (agents) or traders who assumed false names to protect themselves from social stigma. Ironically, the Wall Street of the South was located just several blocks southeast of the capitol itself; it was also close to the canal, several railroad terminals and the ports.

The canal had been an early brainchild of George Washington, who envisioned the James River connecting across the mountains to the Kanawha River. (West Virginia was then still part of the state of Virginia.) It was the first commercially viable canal to open in the newly independent United States, in 1790, although it suffered from construction difficulties and subsequent financial hardships. The Commonwealth of Virginia took over operations in 1820 when the company folded and ultimately completed nearly two hundred miles of canal and river, with locks and other supporting infrastructure. The canal basin in downtown Richmond, the terminus for the canal (the river below that was accessible to deep-water vessels), became a unique center for trade and commerce, with a constant coming and going of bateaux and other boats. The area, only a handful of blocks south of the capitol, was crowded with neighboring shops and businesses.

On the south side of the river, the Manchester Cotton and Woolen Manufacturing Company, opened in 1837, was among the first textile mills to operate in the Richmond area. The company was the first to use the water power developed by the Manchester Canal, which later supplied power for grain, paper, sumac and woodworking facilities. Operations ended in 1890.

The rail era began in Richmond in 1834, when the Richmond, Fredericksburg and Potomac Railroad (RF&P) was chartered by the General Assembly. (The station would be on Broad between Seventh and Eighth.) This line ran between Acquia Creek near Washington and Richmond. It was one of as many as six major railroads that would serve the city by the late twentieth century; there were five major lines on the eve of the Civil War. Original charters included the Richmond and Petersburg Railroad

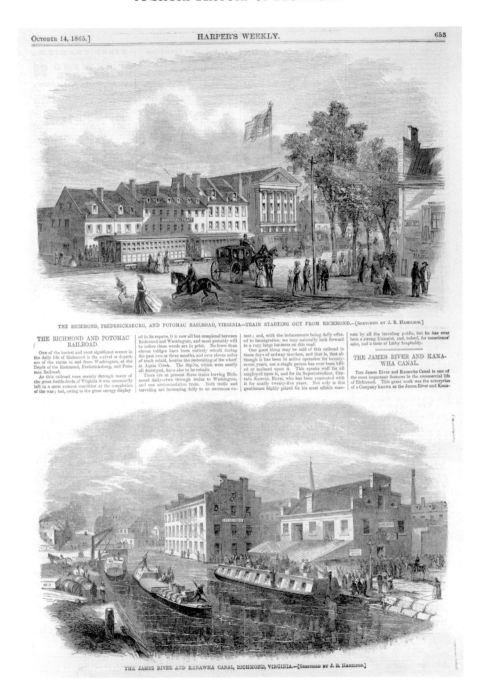

RF&P Railroad train starting out from the James River and Kanawha Canal, October 14, 1865. Sketch by J.R. Hamilton (*Harper's Weekly*). *Library of Congress.*

Manchester Cotton & Woolen Manufacturing Company, south bank of James River at Mayo Bridge. *Library of Congress.*

(1836); the Louisa Railroad, later the Virginia Central Railroad (1836), the Richmond and Danville Railroad (1848) and the Richmond and York River Railroad (1853). In the twentieth century, CSX (a successor line to several of the early roads), along with the RF&P, had its corporate headquarters in Richmond. (CSX is now headquartered in Jacksonville, Florida.) Well-known successor railroads after the Civil War also included the Chesapeake and Ohio Railroad, the Southern Railway, the Norfolk and Western, the Seaboard Coast Line and the Atlantic Coast Line. Amtrak began offering passenger service in Richmond upon its creation in 1971.

Although Richmond was not the only American city with so many rail lines, it was a true southern rail hub—a factor in later moving the Confederate capital there. In addition to private manufacturers of railroad equipment, each line had a series of sorting yards and spurs that dotted the landscape. Each railroad also had its own terminus, warehouses and stations in or near the city—some south of the river—meaning that freight or passengers moving from one line to the other usually had to move by wagon, foot or barge. While this might seem unwieldy to the modern observer, it was a natural outcome of the fierce competition in early rail

Above: Manchester Canal headgate at western end of canal, facing north. *Library of Congress.*

Left: An 1856 advertisement for parts to manufacture trains scanned from an 1850s city directory. *Courtesy of Jack Trammell.*

days to corner markets and develop new routes. It also made for vastly increased human traffic in the center of Richmond that local businesses were continually fueled by.

Richmond also remained an important deep-water port open to oceangoing vessels as far as Rocketts Landing, Manchester and the Fall Line. Before the Civil War, the port of Richmond often exceeded 100,000 tons a year of traffic coming in, with a roughly equal amount going out. During the war, Richmond remained a critical port for the Confederate cause, maintaining trade and contact with the outside world. Richmond retains a deep-water port today, although Norfolk/Newport News downriver sees the majority of modern transoceanic traffic.

Richmond experienced the same changes that many growing American cities did in the antebellum era, with an increasing emphasis on upgrading roads and sidewalks—often composed of dirt and planks—to cobblestone or deck walks; replacing candlelit streetlights with gas lights; providing more organized and efficient city services like policing; and continuing to annex nearby areas for expansion plans to facilitate further growth. Industrialization and commercialization fueled Richmond's prosperity and an expanding middle class.

The Social Fabric

With growth came the need for law enforcement. Although there had been constables and appointed court officials in the early days, by 1807, Richmond had established one of the first "formally organized" urban police forces in the country. According to the departmental history, Richmond built its first official city jail in 1816, a police station along with another jail (both at Broad and Sixth) in 1828 and a second station in 1840. "Officers were appointed from the wards in which they lived with recommendations from five outstanding citizens and the ward alderman." One might think this signaled an increase in crime; rather, the phenomenon mirrored other major cities, where industrialization, expanded commerce and rapid population growth caused a need for protecting tens of thousands of people living in proximity to each other. By the Civil War, the department employed more than forty men.

Social stability was also an issue related to holding a large black population in legal bondage. Colonial Richmond had seen fairly regular

reports of possible slave insurrection, as well as the ubiquitous publication of numerous advertisements for runaway slaves in Richmond newspapers, but no one anticipated the level of hostility, as well as the depth and breadth of planning that almost resulted in a successful 1800 rebellion planned by slave Gabriel Prosser. Prosser, a trusted slave belonging to Thomas Prosser in Henrico County, was elected leader of an increasingly large and widespread group of disaffected slaves who planned to set fire to warehouses in Rocketts and then sweep into Richmond from the north with as many as one thousand men. They intended to massacre as many whites as they could. They also planned to take the governor, James Monroe, hostage. Unfortunately for Prosser, two slaves at the Sheppard plantation gave away the plot on its very eve, and authorities reacted quickly to intervene. In addition, torrential rains blocked Prosser and his men from reaching the city. Although there were perhaps as many as one thousand slaves involved, about three dozen, including Prosser, were tried and hanged (mostly at the site for such purposes at Fifteenth and Broad). For Richmonders and many other Virginians, this failed plot turned the social fabric of the city inside out. A permanent guard was established, and slave laws were abruptly enforced to extremes in a pattern that would be repeated numerous times.

In 1807, Aaron Burr stood trial in Richmond for treason in what Dabney and others have called "the greatest trial of its kind in American history." Although Burr had killed Alexander Hamilton in a duel, perhaps the more serious charge against him was a plot to establish an independent country west of the Appalachians. Chief Justice John Marshall presided over the court as part of his circuit duty. According to Dabney, thousands of interested observers flocked to Richmond by boat or coach, filling local inns and taverns to the bursting point. The jury found Burr "not proved guilty under this indictment by any evidence submitted to us." This was hardly a ringing "not guilty" verdict of the more traditional type, but Marshall carefully directed that those exact words be placed into the record.

Richmond's growth and importance during this period can also be gauged by the attention it received from international visitors and its own celebrities who grew to international prominence. A noteworthy visitor came in 1824, the Marquis de Lafayette, the Revolutionary War general who had fought with George Washington and was present in 1781 at the final victory at Yorktown, an hour or so east of Richmond. His arrival for a fourth visit to Richmond (he had come twice during the war and once

immediately afterward) was greeted with great pomp and circumstance, and he stepped out onto the docks at Rocketts and into a noisy crowd, accompanied by the firing of a booming salute.

The next day, he was escorted to city hall and Capitol Square. There, an old army tent belonging to George Washington was set up, guarded by the Richmond Junior Volunteers (including a fifteen-year-old Edgar Allan Poe). John Marshall delivered a speech. Among Lafayette's other stops during his stay was a dinner at the Masonic Hall and a service at Monumental Church (1224 East Broad Street). In 1825, Lafayette was compelled by popular demand to return for one last visit before returning to Europe. There are few figures in Richmond's long history that compare in terms of popularity and affection to Lafayette. When he died in 1834 in France, an elaborate funeral and memorial were conducted in Richmond, including marching military units and a formal church service.

Antebellum Industry

The James River as it approached the Fall Line was a natural location for mills, and between the Revolutionary War and the War of 1812, dozens were established in the Richmond area. The most successful were located between Hollywood Cemetery and Mayo's Bridge and were owned by a handful of families that would dominate the business, including the Gallego family, which would own a large and famous mill downtown at the canal basin, and the Haxall family. Although tobacco dominated popular culture, Richmond became an American breadbasket, exporting tens of thousands of barrels of flour—242,916 in 1831 alone. "City flour" was generally considered superior by Richmond residents to "country flour," which was less refined and more crudely ground and came downriver by barge for trade. The mills would recover and continue to flourish even after the destruction of the city center in 1865 at the end of the Civil War.

The first steel/iron operation on Belle Isle (originally known as Broad Rock Island and home to an eighteenth-century fishery), a nail factory, began in 1815 during roughly the same period a mill was established on the island. Later, according to the NPS, "Belle Isle Manufacturing Company built the Richmond area's first chartered rolling and puddling mills on the island in the 1840's producing nails, bar iron, boilerplate and other works of iron. This company became the Old Dominion Iron & Nail Works,

Old Bell Tower, circa 1908, Capitol Square. Photo by Detroit Publishing Company. *Library of Congress.*

which by 1860 was one of the premier nail manufacturers in the country and still occupied the island as late as 1910." The nearby Tredegar Iron Works in Richmond on the north bank was founded in 1836. Richmond would increasingly be an industrial city, but it would always be unique, in that a significant portion of its industrial workers consisted of rented black slaves. They sometimes kept part of their pay and sometimes lived semi-independently.

Richmond continued to grow geographically during the antebellum period, with annexations of neighboring land occurring in 1780, 1793

and 1810. After the war, the annexations would continue, with Richmond spreading south of the James River in 1892. Eventually, the city would incorporate almost sixty-three square miles north and south of the James River. Many of Richmond's iconic structures were built in this period. The Bell Tower, for example, was completed in 1824 as part of Capitol Square to warn of fires or danger. The tower remains in Capitol Square today. The Ballard (1856) and Exchange (1841) Hotels were built with a skywalk over the street connecting them.

Important institutions were established during this era. Several doctors from Hampden-Sydney College aspired to start a medical school in Richmond, and in 1838, they took steps to implement this goal. Using rooms at the Eagle Hotel, they improvised and forged ahead. In 1845, the medical

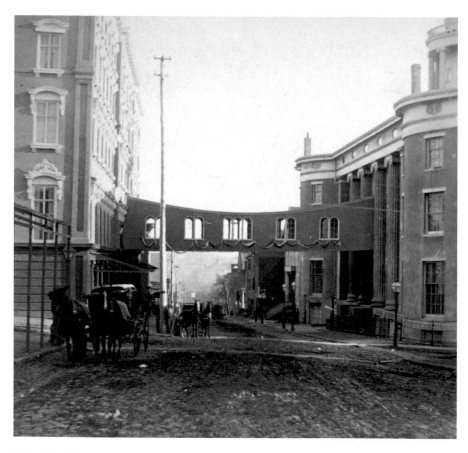

Ballard and Exchange Hotels, showing elevated street crossing. Photo by David H. Anderson (1827–1905). *Library of Congress.*

Left: An 1856 clothing store advertisement, scanned from an 1850s city directory. *Courtesy of Jack Trammell.*

Below: Egyptian Building, Virginia Commonwealth University, 1845. *Photo by Misti Nolen.*

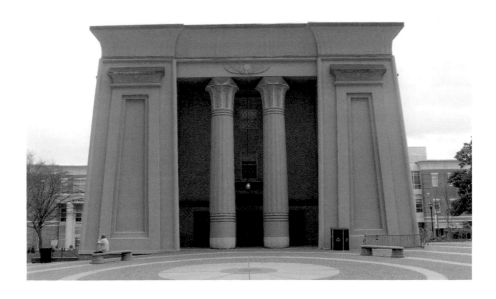

An 1859 chemical advertisement, scanned from an 1850s city directory. *Courtesy of Jack Trammell.*

school moved into the Egyptian Building (1845), a remarkable structure on East Marshall Street built in the ancient temple style. In 1854, the General Assembly sanctioned the school the Medical College of Virginia (MCV), and its affiliation with Hampden-Sydney ended. Eventually, MCV would merge with Virginia Commonwealth University (VCU) and assume a rank among the top medical programs in the country.

Hundreds of small businesses flourished during the antebellum era, ranging from confectioneries to bakeries, from watchmakers to tinkers, from chemists to booksellers. The city directories of the period are filled with their locations and basic demographics, providing ample evidence of vibrant economic activity.

URBAN FEARS

All was not happiness and prosperity, however, during the antebellum era. In addition to the immeasurable human suffering, the other side to being the economic and political center of the slave trade meant an accompanying possibility (real or imagined) of slave revolts or uprisings. Richmond, like Virginia and other southern states in general, was a conservative, "status quo" culture in the antebellum period, though Richmond as the state capital often became the forum where difficult issues of the day burst out into political debate, in the newspapers, in the General Assembly or through public forums. However, the almost

constant fear of slave unrest was a relentless source of conversation, even paranoia, in antebellum Richmond and Virginia.

For the remainder of the antebellum period, Richmonders remained paranoid, periodically increasing police and militia patrols, tightening laws and curfews governing slaves and free blacks and entrenching against any further influence from antislavery forces that continued to grow in other parts of the country and overseas in places like Great Britain. This fear would become a theme throughout Richmond's history until the end of the Civil War abolished slavery and the slave trade.

Events in 1831 would reinforce that caution. Nat Turner was a slave born in Southampton County about the time that Gabriel Prosser was executed in Richmond in 1800. Gifted in unusual ways, many people, including Turner himself, were convinced that he was a real prophet. Following a series of visions, Turner and his converts began a bloody rebellion early in the morning of August 22 that continued across Southside Virginia until armed federal and state authorities arrived to quell it. In the end, fifty-five whites were killed. Later, fifty-five slaves, including Nat Turner, were executed for the immediate crime. Hundreds of others as far away as North Carolina would be falsely accused and executed or murdered by mob violence as the saga, like the Salem witch trails, continued to take on a life of its own.

The reaction in Richmond was electric. The General Assembly received forty petitions asking for slavery and its complications to be dealt with immediately. In January, two resolutions appeared from out of the political chaos—one would reject all petitions for emancipation, and one would take emancipation to the general electorate for a vote. At this moment, Virginians technically considered ending slavery. What happened next was a resounding rejection of that notion: another hardening of slave laws and laws that impacted free blacks (who, it was assumed, were agitating those who were enslaved to revolt). A similar cyclical pattern of coercion and oppression occurred at the city council level in Richmond over the ensuing years.

As with other cities, fire was another constant threat to prosperity and tranquility. Richmond had already had its share of fires, but on December 26, 1811, a fire at the new, brick Richmond Theatre (1810), located between today's Twelfth and College, left a particularly tragic scar on the history of Richmond. Started by a stage equipment malfunction involving the curtain and a flame-lit chandelier, the fire claimed dozens of victims, including sitting Virginia governor George William Smith. According to a contemporary report, "Many were trampled to death under foot, others threw themselves

Monumental Church, built on the ruins of a theater fire and on top of a crypt. *Library of Congress.*

out of the windows and were dashed to pieces on the ground, some with legs [and] arms broken. Many were burnt to death in the boxes and others on the stairways. Later accounts say, 160 skull bones have been found." There are still some disagreements over the final number of victims, although seventy-two is a number commonly reported today. Monumental Church was completed on the site in 1814 in memory of the victims and can still be visited, complete with an underground crypt holding victims' remains.

Richmond was consumed with many issues that resonated in other American cities. In October 1833, for example, a committee of two dozen local men was appointed by a group of citizens to address the growing problem of gambling. They reported back, identifying at least fourteen separate establishments, most of them also housing legitimate businesses, with many on or near E Street, as well as several popular taverns. Committee members were particularly concerned about punishing the guards who controlled entrance to the tables. For slaves guarding game locations, punishment was to be whippings. They recommended establishing legal gambling houses to suppress the illegal ones and thus control the problem, perhaps even taxing them to gain additional city revenue. Their findings were shared with officials, who took the matter under consideration.

LITERARY HAPPENINGS AND OTHER ENTERTAINMENTS

Richmond was also the scene of important literary activity in the antebellum period. American literary icon Edgar Allan Poe grew up and spent much of his career in Richmond. Poe was born in Boston, Massachusetts, but moved to Richmond to be raised by his foster parents, John and Frances Allan, after his parents died. Poe was educated well, attending the University of Virginia, but he was always a troubled soul. His literary accomplishments, including many stories and poems, such as "The Raven," were supplemented by his important work as editor for the *Southern Literary Messenger* and other journals. Most of the homes and places where Poe stayed while in Richmond (including Moldavia, at Fifth and Main, a large home Allan owned) no longer exist. But the mark Poe left on the city is evident everywhere (including the aforementioned Old Stone House, which houses the Poe Museum).

British author Charles Dickens, after visiting places like Boston and Philadelphia, made Richmond his last stop on an American tour in 1842, primarily due to the heat he expected he would have to battle if he continued into the Deep South. Incidentally, he met with Poe in Philadelphia during the six-month tour. Dickens was fascinated by America but very troubled by the "peculiar institution," noting that, "in this district, as in all others where slavery sits brooding...there is an air of ruin and decay abroad, which is inseparable from the system" (as quoted by the Richmond Public Library). Dickens was entertained upon his arrival in Richmond at a large dinner at the Exchange Hotel, and he toured local businesses, including a tobacco factory. Although he saw great beauty, he also saw abject poverty and enslavement. He left unimpressed by Richmond. He was particularly repulsed by men—and some women—constantly spitting streams of brown tobacco juice.

Richmonders had various options for entertainment during the period, ranging from classic theater to the circus, and even more sensational public spectacles, such as when three Spanish pirates were tried and hanged in 1827. According to Dabney, the men had stopped an American ship between Cuba and the United States and murdered the crew members. The assailants were tried in the House of Delegates—the court presided over by Chief Justice Marshall—and the men were sentenced to hang. On August 17, the day of their execution, a large crowd of several thousand people gathered to watch the doomed men ride on their own caskets to the hanging site (the aforementioned site now filled in and lost to the modern observer). "Such grim affairs were considered in that era to be almost festive occasions,"

Dabney wrote. Strangely, some men of medical curiosity experimented with electric shock to see if the executed criminals could be brought back to life afterward, but their experiment failed.

Harkening back to colonial times, many Virginians and Richmonders—along with many in the South in general—were obsessed with horse racing. It was common for dirt tracks to be laid out practically after the first settlement and crop planting were established. In the early nineteenth century, some called Richmond "perhaps the greatest race center in the United States." The oldest racetrack, according to Sanford, was Fairfield, which likely dated to the colonial period, along with other popular tracks like Broad Rock and Tree Hill. Races were set for a marked distance—commonly two miles—and then a series of heats or "rounds" were held, in which the faster and more enduring animal prevailed over several tries (for example, best two of three). Gambling on races was ubiquitous and created a great deal of consternation among certain elements of the population.

Richmond as an "old" city had by this time also become a nineteenth-century city of ghosts and legends. By the antebellum era, some of these stories were nearly two hundred years old and were common knowledge among inhabitants. It was no mistake that the literary king of the macabre, Edgar Allan Poe, hailed from Richmond. But these tales and strange happenings predated Poe, even extending back to Native Americans, who had originally inhabited the area and suggested that the seven hills were home to nature spirits.

The Governor's Mansion, for example, built in 1812 adjacent to the capitol building (and on the site of the former 1779 frame house), was the scene of many strange goings-on. One of the best known and intriguing is an account of audible footsteps accompanied by the swishing of skirts—it was said that young men rose from bed and pursued those sounds, only to find emptiness. An eighteenth-century pastor at St. John's Church, George Keith, earlier made a pact with his military-bound friend, William Frazier. He is quoted by Marguerite Lee as saying, "If one should arise from the dead they would believe." When Keith, a grandfather of John Marshall, was later serving at Hamilton in northern Virginia near the end of his life, Frazier (who had recently died in India) appeared to Keith's servant twice in succession and warned his friend that "religion was true." Keith is reported to have made his own preparations and died only a few months later.

From its inception, Monumental Church, built on the ruins of the great theater fire that took dozens of lives, including that of the governor, had strange sounds and sights associated with it. It no doubt helped the aura

Location of Edgar Allan Poe's mother's house. Photo taken between 1930 and 1939 by Frances Benjamin Johnston (1864–1952). *Library of Congress.*

that the fire victims remain buried in a crypt in the basement of the church. Strange goings-on include the ghostly image of a Revolutionary War soldier that appears in the balcony from time to time (including recently to a television production crew).

The famous Virginia Washington Monument Equestrian Statue at Capitol Square as it appeared at the end of the Civil War. *Library of Congress.*

Tuckahoe Plantation, founded as early as 1689 as an inheritance to Thomas Randolph from his father, William Randolph (of Turkey Island), is a frame plantation home still extant in the west end of Richmond (Henrico County). Colonial-era music, wandering footsteps and a woman in white who is supposedly a lover pining for her romantic paramour appear periodically in the lovely gardens.

Most of all, Richmond represented everything in the antebellum era that America was becoming: capitalized, industrialized, diversified, urbanized and filled with optimism about the possibilities for prosperity. Unfortunately for all Americans, that prosperity had largely been built in both the North and South on the backs of enslaved people. For Richmonders and everyone else, there would be a terrible price to pay, and it would persist long beyond the looming Civil War.

The first commemorative statue in Richmond, of George Washington, was completed in 1857 on the grounds of Capitol Square. Richmond had achieved a level of prosperity that enabled the General Assembly to spend money on a statue made in Germany. The discussion of Confederate statues taking place as this book goes to press really begins with this statue. From a desire to honor heroes from wars originally sprang the idea to honor Confederate notables when Richmond had economically recovered from the Civil War.

3

RICHMOND DURING THE CIVIL WAR PERIOD

It is well that war is so terrible, or we would grow too fond of it.
—*Robert E. Lee*

F ew cities have experienced the range of dramatic events that Richmond witnessed immediately before, during and after the Civil War. A small but prosperous southern city was transformed overnight into the capital of a nation larger than most European countries—industrialized, commercialized, bureaucratized, militarized and more than doubling in population. Richmond was also the economic nerve center of the domestic slave trade, which occupied a central role in the conflict between the sections of the country and made war inevitable. At the end of the war, the most significant parts of Richmond lay in ruins, and the economy was in shambles. And, finally, African-American men and women walked the streets with the knowledge that legalized slavery was formally ended.

Richmond in 1860 was home to 37,910 people, making it the third-largest city in the South behind Charleston, South Carolina (40,522), and New Orleans, Louisiana (168,675). By the start of the war, some sources cite Richmond as having surpassed Charleston and moving into second place. Richmond ranked twenty-fifth overall in the country in population in 1860 but was thirteenth in manufacturing. Of Richmond's inhabitants, 6,358 were classified as foreign-born, 45 percent of them Irish. Roughly 35 percent of the population was African American, including a significant free population that numbered roughly 633 households, or several thousand

Map of Richmond. Illustration appearing in *Harper's Weekly* 6, no. 293 (August 9, 1862). *Library of Congress.*

people, who lived in largely segregated neighborhoods but enjoyed certain degrees of freedom. By 1880, the number of African-American households had jumped to 5,670.

African Americans, both free and enslaved, played a vital role in the late antebellum and wartime history of the city. Due to the "liberalizing" effect of rented industrial slaves, the large free black community and the need for blacks to replace white males who had entered military service, many blacks enjoyed greater degrees of independence immediately before and during the war. The white population, always fearful of rebellion and discord, responded by tightening controls (or, sometimes, attempting to). According to Emory M. Thomas, "The ordinance of 1857 provided for a rigid pass system restricting the rights of slaves to be abroad at night. The same ordinance restricted Negro presence in carriages, public grounds, graveyards, and in any assembly of five or more 'whether free or not.' More than this, Negros were prohibited from smoking in public, swearing, carrying canes, and from purchasing weapons or 'ardent' spirits."

Richmond, highly industrialized before the war, became markedly more so during the war. From the Confederate Laboratory on Brown's Island, where women made 1,200 rifle cartridges a day (and sometimes died in frequent work-related accidents), to the Tredegar Iron Works, where

rented slaves and white immigrant metalworkers manufactured cannons and other heavy war materiel side by side, the city became the industrial backbone of the Confederacy, especially after the early loss of New Orleans. Buttons, uniforms, rail iron, locomotives, tents, harnesses and even bayonets were among the items produced. One official claimed that this production demonstrated that the Confederacy had literally become self-sufficient.

A visitor in June 1861 would have found a bustling, loud, crowded capital city in the center of a growing international news story. There was literally an audible buzz in the air. Richmond was the seat for three governments: city, state and a new nation. Starting in Capitol Square on the hilly lawn and looking south toward the James River tumbling through the rapids at the Fall Line, a visitor would have seen the granite U.S. Custom House (1858) and the popular American Hotel (1840) on Twelfth and Main. Behind that, the Gallego Flour Mills would have risen up nearly ten stories beside the canal basin. Turning westward, the visitor would have first seen the red brick Bell Tower (1824) and, beyond that, St. Paul's Church in Greek Revival style (1845) at Grace and Ninth. At this church, Confederate president Jefferson Davis received news in the spring of 1865 that the Army of Northern Virginia was abandoning the capital.

To the east, the visitor would have seen the ground rapidly fall away toward Shockoe Bottom and a section of town with low buildings and plank fences where polite citizens seldom ventured. This was the primary slave-trading district, where as many as sixty or seventy establishments specialized in direct slave trading or associated businesses. Located almost exclusively in the Wall Street (now Fifteenth Street) area between Fourteenth and Eighteenth Streets, this "Wall Street of the Confederacy" was vital to the Virginia and national economy before the war and later fueled the finances of the new Confederate nation. The irony, of course, is that it was only a few blocks away from city hall and the capitol, where many high ideals were debated as if this was not happening a short distance away.

The slave markets were also located close to Virginia's major banks. Although much of the wealth of the Richmond slave trade was ultimately funneled through northern and even British banks, Thomas reported that "each of the four major Richmond banks boasted more than a million dollars in capital, and the combined capital of the four totaled over ten million." The Richmond slave trade was an industry that dwarfed other industries in terms of raw capitalization, and Richmond was arguably its economic locus.

The famous Tredegar Iron Works, by now a spreading complex of buildings near the river, employed 2,500 people during the war. According to one source, it produced 1,160 cannons and 90 percent of the Confederate cannonballs and shot. The operation, which included many skilled rented slaves, grew so large that it needed its own processes for acquiring food, clothing and other ancillary materials. It was commonly said at the time that the move of the Confederate capital from Montgomery, Alabama, to Richmond was due to the presence of Tredegar in Richmond. "Richmond was the center of [iron] industry south of the Potomac," according to Emory Thomas.

Still, the industrialization, combined with the area's natural beauty, created a memorable impression to anyone who saw it for the first time. According to Thomas, "From a distance Richmond in 1861 gave the Confederate vice-president and other visitors the impression of an emerging, urban metropolis whose mills and market places had not yet overshadowed the taste and natural beauty of their provincial setting."

Many well-known figures from around the South (and a few from the North, as well) began to arrive in Richmond after the Provisional Confederate Congress in Montgomery, Alabama, voted to move the capital here permanently on May 20, 1861. Among those was a quiet former U.S. Army colonel named Robert E. Lee. He had already entered Virginia history for his role in capturing the renegade abolitionist John Brown at Harpers Ferry in 1859. Invited to command Virginia forces by Governor John Letcher, Lee began piecing together the first untested units that would ultimately become the famous Army of Northern Virginia. His initial headquarters was at Mechanics Hall, at Ninth and Main Streets.

The city itself was ably led by longtime mayor Joseph Mayo, who had served since 1853 and would remain mayor when the city surrendered to Union forces in April 1865. Mayo, working in conjunction with the city council, would see an increasing strain placed on city governance as the war progressed, requiring action on everything from curtailing a growing black-market economy to caring for the increasing numbers of destitute and needy refugees, among them many widows of deceased servicemen. The mayor collaborated with fifteen aldermen. Civil affairs also included four layers of courts in the cities, beginning with the Mayor's Court and Hustings Court, a state circuit court and the state Supreme Court of Appeals. Later, Richmond would become home to the United States Court of Appeals for the Fourth Circuit, staffed by ranked judges by the Judiciary Act of 1891, although a predecessor circuit had initially been established in 1869.

Millrace between structures in partial ruins at the Tredegar Iron Works. *Library of Congress.*

Richmond was also the nerve center of a vibrant and extensive free press in the South. The city had 4 major daily newspapers and dozens of smaller, less-regular publications. The big four were the *Richmond Daily Whig* (Robert Ridgeway, editor), the *Daily Dispatch* (James A. Cowardin and John D. Hammersley, editors), the *Daily Richmond Enquirer* (O. Jennings Wise, editor) and the *Richmond Daily Examiner* (John Moncure Daniel, editor). Thomas argues convincingly that the vitality of the press in the city was a significant factor in the choice of Richmond as capital of the Confederacy. The South had as many as 847 newspapers and periodicals on the eve of the war, and many of them were produced in Richmond.

Law enforcement in an expanded wartime city deprived of most of its male population due to military service presented a significant challenge. Richmond's population ballooned during the war, with sometimes more than 100,000 people either resident or temporarily staying for business or as refugees from Union-occupied territory. In 1860, the police force had utilized a staff of more than 40 men to patrol a city of nearly 40,000 people. During the war, officers wore badges and were identified as members of the local militia, subject to call-up for military duty around the capital at any time. During Union colonel Ulric Dahlgren's raid of 1864, for example, many police officers served in the outer defenses.

The force was often overwhelmed by its wartime duties, in spite of an increased staff and reorganization for a larger night force. Although African Americans, free or enslaved, could not technically be policemen, they often served in ancillary roles, as well as serving in the public works, such as gas and water. Despite this and other measures, the military sometimes became involved in helping civil authorities. Matters were complicated by a city council, state government and even Confederate congress that passed laws impacting civil authority in Richmond.

When the city was evacuated in April 1865, the Richmond police force made its best efforts to aid the military in maintaining law and order. When federal authorities took control of the city shortly thereafter and placed it under Union army occupation, the force was officially abolished. It would not be re-organized until 1870, according to the departmental history, when Major John Poe was appointed chief. He is sometimes considered to be the first chief of police in the formal history of the force. In that same year, tragedy struck, as "thirteen officers were killed when a balcony at the state capitol collapsed during a hearing to decide the legitimacy of Richmond's post-war government."

Richmond was the primary target of Union military efforts from the moment it was named as the capital of the new confederacy. Less than ninety miles south of Washington, D.C., and positioned on major rail and stage lines as well as accessible to oceangoing vessels, Richmond was the economic, political and industrial heart of the rebellion, forcing Abraham Lincoln and his generals to go to great lengths to capture it. The war in many ways was the story of capturing Richmond.

From the beginning, Richmond was a capital city that felt under siege. As early as April 21, 1861, citizens were terrified when rumors began that the U.S. gunboat *Pawnee* was steaming up the James River to shell the city into submission and wreak havoc on the populace. Bells tolled, people ran into the streets and curious citizens headed directly to the river. The militia rolled out ancient field pieces, teamsters whipped their wagons up the hill away from the docks and general chaos ensued. It turned out that the rumor was

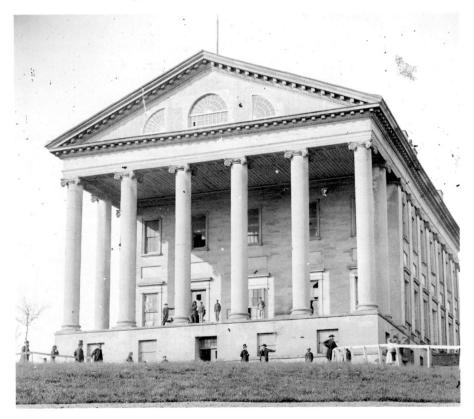

The state and Confederate capitol building (photographed between 1861 and 1865). *Library of Congress.*

false (the *Pawnee* drew too much water to reach the city proper anyway), but the incident set the tone for what would be an endless series of threats.

The first major threat to the city came in the late spring and early summer of 1862, when Union general George B. McClellan moved a massive army of more than 100,000 men by sea to march up the peninsula from Tidewater Virginia, through Williamsburg, to literally within eyesight of Richmond's church spires. People in the city were frantic, and the streets buzzed with military activity. The daily papers were filled with long lists of the dead and dramatic reports from the front lines. Wounded soldiers from General Joseph E. Johnston's Confederate army poured into the city on endless trains of wagons, heightening anxiety.

Many scholars today believe that "Little Mac" missed a golden opportunity to capture the city and possibly end the war early. Instead, a relatively unknown general named Robert E. Lee replaced the wounded Johnston and fought aggressively in the Seven Days Battle to compel McClellan to retreat back down the peninsula, where he soon evacuated his massive army entirely from central Virginia. A legend was made, and the city was saved for another three years of war.

Periodic rumors continued, however, always seeming to many citizens and the media to represent dire threats. In the late spring of 1863, for example, a dramatic raid behind Confederate lines by Union cavalry under General George Stoneman raised the alert in Richmond. Old men and young boys in the militia were called out to earthworks to defend the city. Stoneman's raid ultimately came to grief without directly threatening the city, but it was typical of the alarms that were frequently sounded. In Louisa County at Thompson's Corners, Stoneman slaughtered more than two hundred mules and horses and left them as he retreated, prompting one person to claim it could be smelled in Richmond.

In the spring of 1864, General Judson Kilpatrick led troops on a raid to free Union prisoners in Richmond. Kilpatrick's main corps could not reach Richmond, but a contingent led by Colonel Ulric Dahlgren is significant for two reasons—not just the release of Union prisoners in Richmond at Belle Isle and Libby Prisons but also the outright capture of President Jefferson Davis, who was to be taken north as a prisoner. The raids failed militarily. Dahlgren was not only killed trying to escape, but his remains were also even the occasion for "brutal" treatment due to the controversial texts and information he carried with him. The plan to capture Davis was sensationalized in the press and was the cause for great Southern outrage.

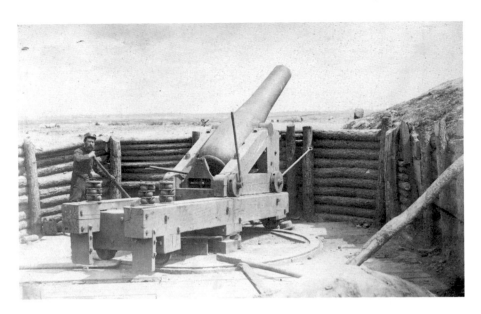

Confederate gun and gunner on duty in front of Fort Hell near Richmond in 1865. *Library of Congress.*

Long before Dahlgren's raid, the city was quickly ringed with trenches and artillery emplacements. By the end of the war, it was—along with Washington, D.C.—probably the most heavily fortified city in modern history before the world wars. Many of the works are still extant and can be visited as part of the National Park Service Richmond Battlefield site. Even the present-day airport with completely modern facilities is surrounded by partially preserved Civil War–era earthworks that can be easily recognized.

The city was an armed camp throughout the war, with units arriving from all over the South to organize, train, arm and equip troops, and these were to eventually join larger Confederate units. Richmond was in every sense the commercial, military, bureaucratic, social and industrial center of the self-declared Confederate nation trying to be independent. Soldiers being soldiers, Richmond was filled even more than normal with horse racing, gambling, prostitution, petty crime and other, more harmless amusements. The provost marshal and police remained extra busy in their work, while permanent residents felt a heightened state of concern.

During the Civil War, Richmond served as a processing center for thousands of Union soldiers taken prisoner on the eastern battlefields and in other combat zones. In addition to being processed and passing through Richmond, many ended up actually staying in Richmond at any of a number

of makeshift facilities set up to hold them. Although the Confederacy ended up with a vast network of formal and semiformal POW camps, because Richmond was close to the enemy and convenient for prisoner exchanges (until they were ended by order of Union general U.S. Grant), a larger number of prisoners spent time there than in most other places in the South.

The prison at Andersonville in Georgia has passed into historic notoriety for its many cruelties, but Richmond had its own terrible stories. Libby Prison, established in a large warehouse, was home to many unhappy prisoners (almost all officers) who knew all too well it was not designed for its purpose. Worse yet, a camp was established on Belle Isle in the middle of the river with no formal facilities. Thousands of mainly enlisted men were exposed to the elements and neglected; hundreds died. Confederate authorities barely placed guards, as anyone attempting to swim the Hollywood rapids invariably drowned. Many tried and failed. Sick and malnourished prisoners were isolated from the public eye, and this also increased neglect. Castle Thunder, a former tobacco warehouse also serving as a slave jail, served as a prisoner-of-war facility at times, as well.

Richmond during the war saw the best and worst of humanity, in exaggerated terms. There were bread riots requiring Confederate president Jefferson Davis to personally intervene with starving women. U.S. president Abraham Lincoln, making a dramatic arrival after Confederate forces evacuated the city, was serenaded by recently freed black slaves. In Richmond, no one day was like another, and everyone knew that they were witnessing events that would likely never be seen again. In the last half of the war, this sense of fate was tinged with depression and a sense of foreboding, characterized by bread and water parties, in which the rich gathered in large homes dressed in party finery to partake of meagre provisions in recognition of the terrible conditions faced by soldiers. Adding to the somber rituals were frequent enemy raids and alarms, as well as gloomy newspaper headlines telling of other cities in the South that were falling one by one.

Nonetheless, "old" Richmonders remained somewhat aloof from the hundreds of refugees, the countless rented industrial wartime slaves and the thousands of wounded, traveling or training soldiers. While every family was touched by military deaths and some form of war-related privation, Richmonders generally attempted to forge on with life as usual to the limited extent that they could, serving on council, running small businesses, passing ordinances, complaining in the newspaper editorials about crime and gossiping endlessly about one another. Although the war ultimately destroyed Richmond in the physical sense, it also transformed the city through the

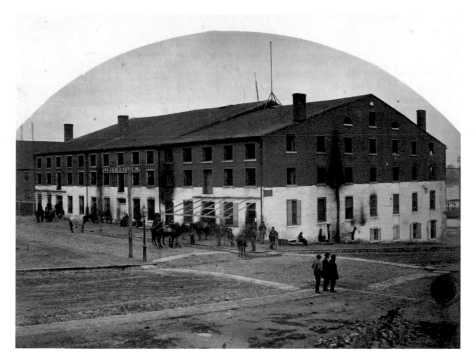

Libby Prison, Confederate military prison established in 1861. *Library of Congress*.

larger-than-life international role it played in the grand unfolding human history of America. Richmond was a temporary home to foreign diplomats, European military officers, coffee traders and other foreign businessmen and literary celebrities, even internationally known circus performers.

Civil War Richmond was also filled with fascinating personalities. In addition to the notables who every student learns about—Robert E. Lee, Stonewall Jackson, Jefferson Davis—there were those whose primary imprint was their role in the social history of Richmond. Elizabeth Van Lew, for example, was the daughter of a successful Richmond hardware businessman. She was sent to obtain a Quaker education in Philadelphia. Upon her return, she became an ardent abolitionist in a city that was making vast fortunes on the slave trade. In fact, an underground movement associated with the Quakers in Richmond worked quietly against the institution of slavery. As for Van Lew, she eventually turned spy for the Union cause during the war and was later rewarded by President Grant with a government position. When she passed away after the war, the city razed the beautiful family home, although it was not in an unsalvageable condition to any degree.

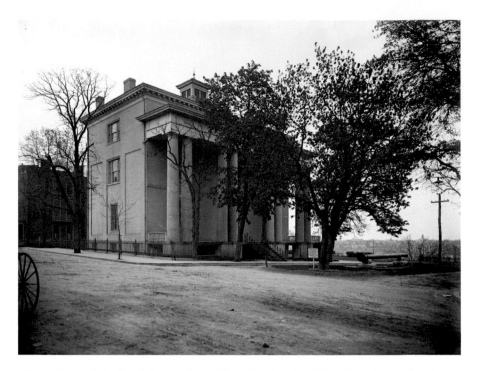

White House of the Confederacy, circa 1930. *1901 photo by William Henry Jackson from the American Civil War Museum.*

General John H. Winder, provost marshal during the war, was another polarizing and dramatic figure. Winder was a lifetime army officer who had served in several prior U.S. wars with distinction, but his ultimate position with the Confederate cause would be in prisoner-of-war management, including at Andersonville, which would forever taint his record. Prior to that, he served as provost marshal in the city of Richmond (1862–64). The ultimate wartime authority, he generated a great deal of consternation with his sometimes arcane policies and bristly personality. These policies ranged from the recycling of uniforms from dead prisoners and Confederate hospital patients (who would want to wear the uniform of someone who had died?), to being too lenient on prostitution, drinking, desertion, gambling and illegal trading. When Winder cracked down on these problems—establishing price controls, for example, or declaring martial law—he was criticized for being too draconian. Few liked Winder, and for his part, he must have felt that he could do nothing right. As a result, Winder was always a subject of local gossip.

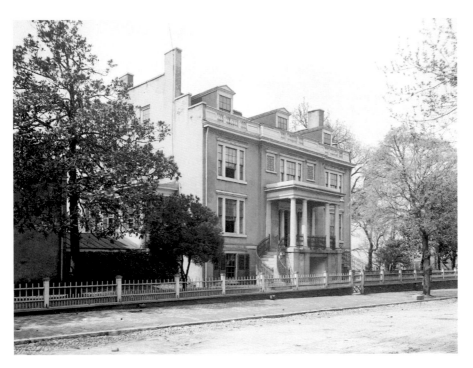

Elizabeth Van Lew mansion, later razed by the City of Richmond. *Library of Congress.*

Richmond become the medical nerve center of the new Confederate nation, with eventually more than fifty separate facilities, including some like Chimborazo (seeing more than 76,000 patients) that were sprawling campuses. The only major permanent medical school in the South, the Medical College of Virginia, was also located there. The main building of the Richmond Almshouse, completed in 1861 and spanning Second to Fourth Streets, became "General Hospital Number One," or "The General Hospital." This hospital had five hundred beds. After the main campus of the Virginia Military Institute was burned in 1864 in Lexington, it also served as temporary home to the cadets. In all, records suggest that Richmond hospitals likely treated more than 300,000 patients during the war, counting repeats and including countless thousands of Union prisoners, as well. The system, as described in the *Encyclopedia Virginia*, was vast and extensive:

> *The Confederate medical centers, most notably Richmond, soon established large pavilion-style hospitals. They consisted of a hundred or more independent wooden barracks that were kept well ventilated and*

Chimborazo Hospital (Confederate) at the end of the war, 1865. *Library of Congress.*

Shockhoe Almshouse/Shockhoe Apartments, 2017. *Photo by Misti Nolen.*

drained, and could be easily isolated in case of disease outbreak or fire. The hospitals purchased foods locally; maintained vegetable gardens, herds of dairy cows, and ample supplies of fresh water; and even boasted icehouses and breweries. Altogether, the patients who recovered did so because the hospital removed them from the environment that had contributed so much to their illness. Two of these large hospitals, Chimborazo and Winder, are still considered to be the largest ever constructed in the Western Hemisphere.

African Americans played an important role in the Richmond healthcare system. Enslaved and hired freed people, both male and female, often staffed the medical centers, cooking, cleaning wounds and generally running the day-to-day business that did not require the presence of a trained surgeon. Other women in the community baked goods, sewed uniforms and sent books and other tokens of comfort. The care of the wounded was a major community-wide effort supported by the full resources of the army, city and government. The Medical College of Virginia remained open during the entire war and was the only such facility within the Confederate nation. According to the college's own written history: "One of MCV's doctors, Dr. Hunter McGuire, was General TJ 'Stonewall' Jackson's personal physician. The turmoil of war, inflation and worthless Confederate currency caused MCV hospital to sacrifice its ambulance horse for enough money to remain in operation."

The war years took an immense toll on everyone in and around the city. In March and April 1863, conditions deteriorated in Richmond and in other cities as a result of food and other staple shortages, inflation, military defeats and a general despondency and disillusionment. In Richmond, this resulted in a series of civil disturbances exemplified by the bread riots. On April 2, matters came to a head as five thousand citizens, mostly women, took to the streets and began breaking into shops and taking everything from basic foodstuffs to jewelry. President Jefferson Davis left his own offices and pleaded in person with the crowd, the mayor read the riot act and the militia soon arrived to restore order. Nonetheless, it was clear to everyone that Richmond was stretched to the breaking point. Only Lee's victory at Chancellorsville and invasion of Pennsylvania, along with a more promising harvest, would provide some temporary relief.

The Siege of Petersburg (1864–65) brought modern siege warfare within earshot of city inhabitants. There were daily artillery duels, with an occasional shell coming within the city limits, and miles of manned

trenches and obstacles created to make attack difficult. Combined with an uncharacteristically bitter winter, suffering increased both in and out of the army. Attempting to break the Danville-to-Richmond rail line, Grant extended Lee's siege lines farther to the west. There was finally a breakthrough on April 2, 1865. Lee sent a message to President Davis, who was worshipping in St. Paul's when he received it. The city was to be evacuated.

The war years were eventful, and everyone who lived through them or visited the city had a great impression made upon them; they witnessed sights they would never forget. All of this ended abruptly and violently. On April 3, 1865, it ended in flames and military conquest. Sallie Putnam, a

Mayo's Bridge in ruins in 1865. *Library of Congress.*

Richmonder who kept a diary during the war, described it this way, as cited by the NPS:

> *As the sun rose on Richmond, such a spectacle was presented as can never be forgotten by those who witnessed it....All the horrors of the final conflagration, when the earth shall be wrapped in "flames and melt with fervent heat," were, it seemed to us, prefigured in our capital. The roaring, crackling and hissing of the flames, the bursting of shells at the Confederate Arsenal, the sounds of the Instruments of martial music, the neighing of the horses, the shoutings of the multitudes...gave an idea of all the horrors of Pandemonium. Above all this scene of terror, hung a black shroud of smoke through which the sun shone with a lurid angry glare like an immense ball of blood that emitted sullen rays of light, as if loath to shine over a scene so appalling....*[Then] *a cry was raised: "The Yankees! The Yankees are coming!"*

For Richmond, a new chapter was opening. The Confederate state of Richmond, so-called by Emory Thomas, was gone, and the new Richmond as part of the restored Union would soon be rebuilt on the ashes of war. Richmond and the "Lost Cause" would take control of the past and the future for a period of time, but the longer struggle for Richmond as a free city would continue. And it continues now into the present days as a result of the wartime experience.

RICHMOND FALLS
THEN PULLS ITSELF UP

The dogmas of the quiet past are inadequate to the stormy present. The occasion is piled high with difficulty, and we must rise with the occasion. As our case is new, so we must think anew and act anew.
—Abraham Lincoln

THE FALL OF RICHMOND

In March 1865, the city was weak inside and out. Richmond's population had almost tripled between 1860 and 1865, going from 37,910 to about 100,000. The city did not have the resources to build the infrastructure necessary to support its population at any time during that period, especially with 10,000 wounded soldiers in forty-four hospitals and 10,000 military prisoners weighing it down. Virginius Dabney said, "The last winter of the war found the Confederate capital shabby and down-at-heel, its people hungry and cold, its houses in need of paint, its crime-ridden streets dirty and unlighted."

On Sunday, April 2, 1865, while attending St. Paul's Church, President Jefferson Davis received a message from General Lee that Petersburg was about to fall and Richmond would have to be evacuated. Mrs. Davis had already left the city with their children. No city defended by a disintegrating army can logically plan for its demise without creating a panic or appearing

disloyal. In Richmond, the only plans in place were for the army to destroy ammunition, equipment and food supplies that the enemy might use. There was a degree of belief that somehow the war would continue in other parts of the Confederacy. In the city, there were Unionists, slaves hungry for freedom and freedmen who looked forward to a more equal society. The other portion of the populace was concerned with the unknown impact of a Union occupation and the changes coming to the only way of life they had ever known.

Sunday, April 2, 1865, came to be known as Evacuation Sunday. The note from Lee read in part, "I see no prospect of doing more than holding our position here till night. I am not certain that I can do that....I advise that all preparation be made for leaving Richmond to-night." Jefferson Davis expected that Lee could provide several days' warning. How could the Confederate government or any government adequately pack up in one day and leave town? Davis called a cabinet meeting in the former Custom House at the base of Capitol Square, inviting Governor Smith and Mayor Mayo. He relayed Lee's message and ordered an evacuation for that night. Confederate general Richard Ewell received orders to leave with his troops, numbering only about five thousand, after dark. Twilight would come about 7:00 p.m., but the moon would still be visible until 1:26 a.m. the next day. All day, the Confederate Treasury boxed gold coins and other bullion into strongboxes, burned records or paper currency and packed other records that would go on the second of two trains headed to Danville. The war department had been boxing and sending documents to Lynchburg for several weeks. What they couldn't fit into the two boxcars allotted to them, they piled in the street and set on fire. Additionally, there were still prisoners being sent to Richmond from fighting in Petersburg while Robert Ould, the Confederate agent for prisoner exchange, continued to make plans to load new prisoners on to the *William Allison*, a flag-of-truce steamship. No one could issue and deliver enough orders to stop the machinery of war instantly.

At four o'clock in the afternoon, Mayor Mayo called a meeting of the city council on the upper floor of the capitol. Their primary decision was to destroy the liquor supply to prevent citizens from getting drunk and looting. But they avoided the most critical item—arranging to surrender the city. Information was sketchy and contradictory, leading to disjointed actions by those still working to support the Confederate effort. General Ewell gave orders to burn the government tobacco warehouses and to set fire to Mayo's Bridge once the last of the army's rear guard passed.

Amid the chaos, the wife and children of General A.P. Hill, who had been killed earlier on Sunday, rode in a wagon with his body back to Richmond, anticipating burial in Hollywood Cemetery. When the wagon reached the south end of the bridge, it had to wait until after midnight, long enough for the torrent of southbound traffic to abate. They took the body to a building on Capitol Square and then set out to find a pine casket. They went to Belvin's furniture store and, when no one answered, went in anyway. They found an undersized box and struggled to get the body inside. There was now no way to get to Hollywood Cemetery, so they turned around, heading to the family home back across the bridge, this time going south with the flow of traffic. His remains were reinterred in 1891 at the intersection of Laburnum Avenue and Hermitage Road in a monument paid for by Lewis Ginter.

Peter Helms Mayo, a twenty-nine-year-old officer assigned to the department of transportation, received word to organize two trains—one for government officials and one for bullion and records—to leave that night for Danville. Since it was a Sunday, he used the whistle of an old shifting engine to signal workers to gather at the station. They put together the required trains that were then loaded that night. Since the Danville line was in poor shape, the train could go only about ten miles an hour and had to make frequent stops for wood and water, as these were steam engines. After the war, Mayo returned to his family's tobacco business and became wealthy. (He is sometimes credited with inventing the cigarette.) After his death in 1920, his daughters donated his house, acquired in 1884 and located at 110 East Franklin Street, across the street from the Jefferson Hotel, to the Episcopal Diocese of Virginia, where it remains in use.

Libby Prison was evacuated, and prisoners departed on a flag-of-truce boat that had been sent with supplies collected from Northern charities. Everyone that day—whether prisoner, slave, soldier, citizen, upper-class citizen, working-class citizen, Confederate, Unionist, burglar or freedman—was heading somewhere. The state penitentiary held no prisoners, either, after a few inmates got out of their cells and forced the guards to give them keys to the other cells. About three hundred inmates took to the streets. Slaves purchased at the auction on Saturday were quickly sent out of the city. Only fifty slaves—men, women and children—remained at Lumpkin's jail after they were refused space on the last trains out of the city. Mr. Lumpkin tried to preserve his "inventory," since they would be of no value to him the next day! Until

the last minute, most Southerners believed their way of life would continue somewhere—additional proof that war would be the only way to bring about this tumultuous change.

Outside the city, Union general Godfrey Weitzel knew that the Confederate lines had been broken, but he was unsure what defenses remained around Richmond. Confederate forces started fires to try to indicate that many encampments were still in place while also loading wagons to make retreat. The sounds of creaking wagons, braying mules and soldiers cursing and giving orders should have been sufficient to alert Union forces, but the Union troops remained wary of the potential strength of the Confederate lines. Weitzel, a cautious man by nature, was also aware of the way Confederates used sharpened stakes and explosive antipersonnel mines—these could could cause significant Union losses during an attack. His observers, using field glasses, counted thirty-eight railcars of troops headed south from Richmond. He was not certain enough that Confederate troops were abandoning their defenses to order an attack. Union officer George Bruce of the Thirteenth New Hampshire encountered Rebel deserters at 3:30 a.m. on Monday. These men said the Confederates had evacuated the whole line. By then, fires could be seen in Richmond. Weitzel sent four men forward, who returned to confirm that the closest Confederate forts were empty. At 4:30 a.m., Weitzel telegraphed Grant that the front seemed to be undefended and he would move his men forward at daybreak.

The worst day of the city's history began about midnight on April 2, when the plan the city council had made to maintain order did not work. It planned to give receipts for whiskey and other alcoholic beverages to the owners of the spirits located in warehouses and then smash the casks with axes, dumping the liquids into the street. Troops who had deserted their units wandered the streets, as did citizens looking for information and preparing to leave. Others wandering the streets included escaped prisoners, patients who had left the hospitals, looters, Union sympathizers and slaves or freedmen witnessing the beginning of a new era. The city had not yet begun to burn. As the authorities began to destroy liquor supplies, reports said people scooped up liquor by any means available out of the street. This day resembled what happens when a pressure cooker explodes—all the separate ingredients held together by laws, metropolitan police and troops were loosed upon the streets. Thousands of citizens feared African-American regiments of the Union army would take charge of the city.

The destruction that Richmond experienced occurred in phases. The first phase included inmates setting fire to the state penitentiary, mobs roaming the streets, the botched destruction of liquor supplies and general looting. The main powder magazine on Shockhoe Hill blew up in the middle of the night on Monday. Since the structure was situated on the hillside in a ravine, the destruction was limited, though the blast knocked out windows in the nearby almshouse. Cadets from VMI had been stationed there but, luckily, were away, assigned to the front. The reverberation could be heard across the city.

The second phase included the destruction of the Confederate ships anchored at Richmond. The ships were set with explosives. At 3:00 a.m., a Union patrol ship snagged a raft used to make repairs. This alerted the Union troops to what was going on. About an hour and a half later, the explosions started to go off.

The third and final phase occurred when General Ewell gave the orders to set fire to the tobacco warehouses and bridges over the river. As fate would have it, a strong breeze came up and spread the fires all over the business district. Bituminous paper or canvas that formed the roofs of some warehouses created flaming flakes that the wind carried to nearby roofs. Dr. William P. Palmer described this phenomenon "like Greek fire to every neighboring roof and cornice and gable."

The Surrender of Richmond

Early on the morning of Monday, April 3, Mayor Mayo and some members of the city council headed out in a wagon to surrender to the Union army. The city was in turmoil, and fires were raging. They had no flag of surrender, so they tore off their shirttails to accumulate enough material to create a makeshift white flag. Later that morning, General Weitzel met them to accept their formal surrender. Union forces under his command took over administration of the city. The *New York Times* reported:

> *After the surrender of the city, and its occupation by Gen. WEITZEL, about 10 o'clock, vigorous efforts were set on foot to stop the progress of the flames. The soldiers reinforced the fire brigade, and labored nobly, and with great success. The flames east on Main-street, were checked by the blowing up of the Traders' Bank about noon.*

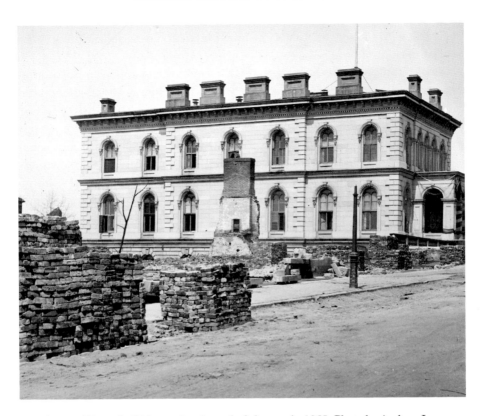

The Custom House in Richmond at the end of the war in 1865. Photo by Andrew J. Russell, April 1865. *Library of Congress.*

The flames gradually died out at various points as material failed for them to feed upon; but in particular localities the work of destruction went on until towards 3 or four o'clock, when the mastery of the flames was obtained, and Richmond was safe from utter desolation.

The scene was a mixture of sadness by those who had lost so much and ecstasy on the part of former slaves who watched Union troops move into the city. The Union army focused on the task of putting out fires, but so many hoses had been cut by mobs that fire brigades composed of regular members and Union troops could only create fire breaks to stop the spread of flames. The entire business district burned down. About nine hundred buildings and their contents were destroyed. Only the granite Custom House at the foot of Capitol Hill still stood. Everything else around it was flattened. Under General Weitzel's command, troops

behaved with utmost correctness and began to provide rations to the remaining population.

The seemingly unified character of the city immediately crumbled upon surrender. The city was like oil and water. Confederate loyalists became bitter and dispirited. Formerly enslaved people were ecstatic at the fall of the city and Unionists finally could express their true feelings. Union troops were greeted by flags being displayed that had been hidden for many years. Union troops sent to protect Elizabeth Van Lew from vengeful Confederates found a large Union flag flying from the roof of her Church Hill home and had no doubt which house they were to protect. There remains only conjecture about who put the Stars and Stripes on the capitol on April 3. Richard G. Forrester, a seventeen-year-old mulatto grandson of a freed woman named Nelly Forrester, claimed he put the flag up. His grandfather was Gustavus Myers, a Jewish lawyer, state legislator and defender of many enslaved persons before Mayor Mayo's court. Richard, who probably passed as white, served as a legislative page and saved the Union flag that had been taken down and thrown on a pile of rubbish when Virginia seceded. He retrieved the flag that day and hid it under his mattress. He raised the Stars and Stripes but was accosted by Lieutenant Royal Prescott, who made Richard take it down. Prescott took possession of that flag. When Union majors E.E. Graves and Atherton Stevens arrived, they saw no flag over the capitol, so they ran up two small guidons (pennants that narrow to a point carried by cavalry units). It was finally Lieutenants Johnston de Peyster and Loomis Langdon who hoisted a large Union flag, marking the finality of the day. Once the Union flag appeared, many citizens felt the dejection of the defeated. Sallie Putnam wrote, "For us it was a requiem for buried hopes." There were those Confederates who held on to the hope that Lee would yet score some miraculous victory in the field. However, Lee surrendered on Sunday, April 9, though word of the surrender did not get to most citizens until the following week.

LINCOLN VISITS RICHMOND

On Tuesday, April 4, President Lincoln came to Richmond along with his son Tad. Lincoln walked from his ship at Rocketts Landing to the White House of the Confederacy. It was a dangerous walk—escaped convicts, Confederate sympathizers and looters were nearby. He was accompanied

by only a dozen crewmen from the ship. His progress was slowed by many admiring and grateful African Americans pressing in to see him. He turned north at Twelfth Street and, at Governor Street, was met by a detachment of cavalry that guarded him the rest of the time. It is a mile-long walk, not far in a time when walking was often the only way to get somewhere, but the elevation rises one hundred feet above these streets in this area. Lincoln was fifty-six years old, and it was no small feat for him. He went to the White House of the Confederacy, where others with him had a drink; he declined. He must have long pondered the cost to sit in the chair Jeff Davis had used and look out those same windows. In the afternoon, he drove around Richmond in an open carriage escorted by African American cavalrymen. Lincoln had lost his son Willie in 1862 to illness, likely typhoid fever. Tad, the youngest son, took ill as well but recovered. Lincoln was beyond fear by this time of his life. Here was Tad with his father in hostile territory before Lee had surrendered.

Lincoln, by these actions, must surely have been full of hope that he could peacefully reunite the nation. He spoke in Capitol Square, but no one thought to take down his words. Admiral Porter's recollection of a portion of what Lincoln said to the crowd of mostly formerly enslaved persons was, "[You can] cast off the name of slave and trample upon it.... Liberty is your birthright. God gave it to you as he gave it to others, and it is a sin that you have been deprived of it for so many years." Lincoln was advised to spend the night on the ship and not in the city. He left the next day to return to Washington.

Richmond's Turmoil

Richmond was a mess both psychologically and physically. Union troops and those that the army hired began the work of restoring the capital. The first priority among many was to pull down walls and chimneys of burned-out buildings so they would not fall randomly. Four-fifths of the city's food supply had been destroyed, and many inhabitants went to Capitol Square for handouts of cornmeal and codfish—the only ready supplies the Union army had. The army did not authorize Weitzel to give food to civilians, but he devised a clever (and humanitarian) plan to sell tobacco that had not been destroyed for cash and use those funds for food to distribute. The U.S. Sanitary Commission and U.S. Christian Commission also provided

food to civilians, patients and Confederate prisoners—usually deserters the Union army had rounded up and put into Libby Prison, which they called "Hotel de Libby."

The Relief Commission later reported issuing 128,132 rations during the first seventeen days of occupation, which works out to only about 7,500 meals a day—hardly enough to feed all those in need across the city. Yankee traders also came to Richmond and set up stores, but most Richmonders did not have money, especially Federal dollars (greenbacks).

Soldiers wounded in the last fighting in Petersburg continued to die. Marion Fitzpatrick had been shot in his upper thigh. William Fields, a Virginia private, accompanied him back to Richmond on the train. Fitzpatrick died from his wounds. Fields wrote to Mrs. Fitzpatrick, "There wer ladies with him all the tim and surgeons, but his wright thy was shattered all to pieces an recovery was impossible as it was so high up that it could not be taken off." He goes on to relate that when Fitzpatrick died on Thursday, he sang a verse from an Isaac Watts hymn, "Jesus can make a dying bed / Feel soft as downy pillows are." Deep faith among Confederates, Unionists and enslaved people comforted many during these difficult times. Many enslaved people thanked the Lord for their deliverance.

In the weeks after occupation, churches became another kind of battlefield. Edward Ripley, a twenty-five-year-old brevet brigadier general (brevet was a temporary promotion in lieu of medals for valor) from Vermont, summoned Richmond clergy and said they could reopen their churches but warned them the army would allow no disloyal words to be spoken. Charles Minnigerode, the rector of St. Paul's Episcopal, said they could not change the liturgy without permission from the bishop, who at that time was in Canada. The result was to omit an explicit prayer for Davis, but also not to add one for Lincoln. Instead, the prayer would be to "bless all Christian rulers and magistrates." Churches were able to reopen for regular services on April 9. Every element of Confederate society had become a part of the total war effort.

The euphoria and support shown to Union troops by former enslaved persons and Union loyalists gave the false impression that most citizens were glad for the change. Captain Linus Sherman felt citizens were glad to see them "because they have suffered so much." The majority view did not match Sherman's instincts. Whites exhibited both resentment and an inability to comprehend what formerly enslaved persons felt. Many held on to hope for a Confederate resurgence. Kate Rowland wrote in her diary on Monday, "I believe Lee will give them a lesson." War and its consequences

did not appear as much in the press as it would today. Jefferson Davis wrote from Danville, "We have now entered upon a new phase of a struggle... nothing is now needed to render our triumph certain but the exhibition of our own unquenchable resolve. Let us but will it, and we are free." Meanwhile, on April 7, Grant sent a message asking Lee to surrender: "The result of the last week must convince you of the hopelessness of further resistance. I regard it as my duty to shift from myself the responsibility of any further effusion of blood by asking of you the surrender of that portion of the Confederate States army known as the Army of Northern Virginia." Lee, too, realized that the cost of further resistance was only more needless death from those who had already given so much. Shortly after churches in Richmond let out, Lee's Army of Northern Virginia surrendered to Grant at Appomattox Court House on Sunday afternoon, April 9. There could be no doubt the war had ended.

African-American churches for decades had been able to hold services, but their ministers were required to be white. April 9, 1865, was also Palm Sunday. Robert Ryland, pastor of the African Baptist Church, that day warned his congregants against the United States Colored Troops recruiting

Hebrew Cemetery, Confederate dead, circa 1865. *Photo by Misti Nolen.*

officers. African-American officers in attendance, furious over such a remark, tried to arrest the pastor after the service. Other parishioners persuaded them to spare Ryland that indignity due to his age. Ryland never preached there again. Like so many whites of that time, Ryland could not fathom the loathing that African Americans felt for being enslaved and their exultation at the demise of slavery.

Northern tourists flocked to Richmond as soon as they could. Driven by curiosity mixed with a degree of gloating, tourists took anything not nailed down. There was a report of a human bone being brought back from a visit to nearby battlefields, along with minié balls and shell fragments. Francis Parkman, the great historian, with just $500 could purchase enough maps and other artifacts to establish the Boston Athenaeum's vast collections, including a perfect run of the *Richmond Examiner*, a paper that supported the Confederacy but was critical of Jefferson Davis. Its editor, John Moncure Daniel, died on March 30, 1865, three days before Richmond fell. Many items left Richmond as trophies, and many other artifacts were lost or destroyed because they had no immediate value.

In May 1865, the victorious Union armies passed through Richmond and were reviewed by Generals George Meade and Henry Halleck. The Army of the Potomac consisted of fifty thousand men in uniform. It took most of the day for their line to pass. They were followed by Sherman's army, and on the following day, Sheridan came through with about eight thousand cavalrymen. This was the final proof if any was still needed that there could be no more resistance.

A year later, on April 2, 1866, African Americans held their first Emancipation Day celebration, not to celebrate the fall of Richmond but to honor the inauguration of their freedom.

CLEANUP AND RESTORATION BEGIN

When an area and a people have been weakened like this, new structures—both physical and social—will arise to take up where the former way of life had stopped. Optimism is a funny thing across America—it just keeps coming up over and over, the same way pine trees in Virginia grow wherever there is an open patch of ground. Some citizens of Richmond immediately began the work of rebuilding. The provisional governor of Virginia, Francis H. Pierpont, arrived in town on May 26. He was a sincere and honest man who did much to establish infrastructure to

alleviate the suffering of both African Americans and whites. A sense of stability enabled entrepreneurial activities to resurface. The First National Bank of Richmond was organized at a meeting prior to the appointment of the provisional governor on April 24 in Washington, D.C. The bank opened on May 10 in the Custom House. It grew and merged over the years; today, it is part of the Bank of America system.

Tredegar Iron Works was an essential piece of the Confederate war effort. Joseph Reid Anderson, owner of Tredegar, got mixed signals about whether the retreating Confederate troops would destroy the foundry. He took no chances and armed several of his workers with orders to remain on guard all night so that the factory would not be destroyed or looted. He had also acted in a prescient manner to protect his investment. Before the war broke out, Anderson and his associates shipped as much cotton as they could to London with the provision that they be paid at the end of the war. This enabled the firm to receive $190,000 in greenbacks in 1865—a considerable sum at the time. Parts of Tredegar went back into production by August 1865. Tobacconist James Thomas Jr. followed the same logic as Anderson and shipped as much tobacco overseas as he could, with the stipulation that he would be paid at the end of hostilities. While Thomas lost $1 million in the war, he could rebuild his fortune with the capital he had prudently sequestered overseas. He immediately got back into the tobacco business, along with many others. By 1870, Richmond had thirty-eight tobacco factories that together employed more than four thousand people.

Richmond had available a unique resource that provided a cheap and strong material to use to rebuild so many factories and buildings: heart pine, wood from virgin pine forests. Pine trees had grown in Virginia for many hundreds of years. Since no one was around to cut them down, the trees grew slowly. Year by year, pines in the forests of Virginia added dense rings as their circumferences expanded. They were also heavy with resin, making them resistant to fire. Today, inside the many old tobacco factories that have been converted to apartments, large timbers still support the buildings. This same resource was available all over the southern United States as well. Many buildings constructed from heart pine remain. Many houses, too, were rebuilt from this material.

The primary pillars of the economy remained, having survived the war. Regional railroads had suffered greatly during the war but were rapidly rebuilt and put back into service. Planters National Bank got its start in December 1865. Eleven banks were in operation by the middle of 1867. The Gallego flour mill burned on April 2, 1865, and had to be rebuilt. The

Left: Sketch of a water wheel in the 1865 Gallego Flour Mill complex. *Library of Congress*.

Below: Details in interior of Gallego Flour Mill after evacuation fire, 1865. *Library of Congress*.

Haxall-Crenshaw flour mill survived the war. Much like Anderson and Thomas, their owners had deposited payments for their products in overseas banks during the war. According to Virginius Dabney, freedmen, most of whom had little capital, quickly established businesses such as barbershops, restaurants, retail stores and real estate operations. Additionally, many former enslaved persons found work as contractors, laborers, seamstresses, household workers and similar roles. Additionally, the population of Richmond, which may have exceeded 100,000 by the fall of Richmond, returned to more normal levels and stood at 51,038 in 1870, according to the U.S. Census Bureau. The population was 37,910 in 1860. Richmond returned to its normal patterns after the Federal Garrison withdrew, and Military District No. 1 ceased in 1870.

THE FOUNDING OF VIRGINIA UNION UNIVERSITY

Shortly after Richmond was taken, representatives from the American Baptist Home Mission Society arrived to serve as both missionaries and, more importantly, teachers. By November 1865, the society had established, and was officially holding classes for, Richmond Theological School for Freedmen, one of the four institutions forming the "Union" that gives the university its name. The permanent school was fully established on May 13, 1867, by Dr. Nathaniel Colver, an elderly, hard-bitten abolitionist who could not be intimidated by anyone. Interestingly, he held classes in the former Lumpkin's jail, where enslaved people had been held before being sold before the end of the war. He rented space in "The Devil's Half Acre" at Fifteenth and Franklin Streets from Mrs. Lumpkin, wife of the notorious Robert Lumpkin. The location was named the Richmond Theological School for Freedmen. Because Dr. Colver was not in good health, he turned over the school in 1868 to Dr. Charles Henry Corey, who headed the school for the next thirty-one years. In 1870, the school moved to the former United States Hotel, also known as the Union Hotel, at Nineteenth and Main. The school was incorporated in 1876 by the General Assembly under the name Richmond Institute.

Rebuilding on Old Foundations

Rebuilding and restoring took place at every level. The Freedmen's Bureau, though it lasted only a year after Lincoln's assassination, sent idealistic teachers and others. Employees of the agency provided schooling, healthcare and food for many African Americans. Confederates, although defeated and forced to sign a loyalty oath, had not altered their view of the world. Education both public and private experienced an upturn. The Richmond Institute is but one example. Richmond College (today the University of Richmond), used as a hospital during the war, opened again in October 1865. The Medical College of Virginia, the only continuously operating medical college in the South during the war, returned to more normal activities. Public schools in Richmond were established in 1869. Private schools sprang up here and there. Reverend John Peyton McGuire, headmaster of Episcopal High School at the beginning of the war, founded an academy that survived until 1942 as McGuire's University School, later run by his grandson. The school later closed because of fiscal difficulties.

Almost all newspapers were wiped out during the fire except for the *Richmond Whig*. Its building was spared, and it published the next day because its owner, William Ira Smith, approached the military governor, General George Foster Shepley, about resuming publication. It promised to support the Union and did not risk offending the military governor's sensibilities. The paper accepted chits for payment in thirty days since no one had greenbacks except the military. The paper heaped blame for the destruction of the city at the feet of Jefferson Davis, who approved the decision to burn warehouses. Other newspapers lost not only their offices but also paper stock, and lead type used for printing often melted. For other newspapers, the mechanics of publishing was the smaller hurdle. They had to agree not to express sentiments unfavorable to the military governor. Reporting and printing was a difficult business, and as Richmond's population returned to normal levels, several newspapers went out of business. War was good for the newspaper business, but normal times, not so much. There were as many as seven morning papers and one evening paper following the war.

One business that hardly skipped a beat was prostitution. Most brothels were in houses that had escaped the fire along Locust Alley. The need to obtain greenbacks incentivized the business. The downside of this situation was that an estimated one-third of veterans carried venereal diseases back home with them to wives and girlfriends.

Within a year, opposition to the new status of freedmen and African Americans in general began to appear as soon as the sword was removed from the throats of whites. The press was almost unanimous in its disdain for African-American voting rights. The *Richmond Times* said, "The former masters of Negroes in Virginia have no feeling of unkindness toward them, and they will give them all the encouragement they deserve, but they will not permit them to exercise the right of suffrage, nor will they treat them as anything but 'free Negroes.' They are laborers who are to be paid for their services…but vote they shall not." Opposition to African-American suffrage would persist for another hundred years.

In 1866, Governor Pierpont urged the General Assembly to adopt the Fourteenth Amendment to provide equal protection under the law and citizenship to anyone born in the United States. Not only Virginia but also all Confederate states rejected the amendment. It did pass in 1868, because Congress denied Southern states representation in Congress until they did ratify it. At this point, Virginia became Military District No. 1, overseen by General John M. Schofield. He, like Governor Pierpont, was an honest and understanding man. Richmond was not a peaceful, pleasant place to be during much of this time.

ROLL, JORDAN, ROLL

Freedmen had a brief taste of political power after the war, but it did not last. Before the war, African Americans had to carry a pass to move about the city. Because of the fear of disorder and the need to simply administer city operations, Governor Pierpont reappointed Joseph Mayo as mayor. Mayo, with cooperation from federal authorities, reinstituted the pass system. It was onerous. If African Americans did not have passes, they were arrested. On June 7, 1865, eight hundred men, women and children were arrested by occupying troops and local police for not carrying passes. Community leaders sent a letter to the *New York Tribune* and organized a petition to President Andrew Johnson. As a result, Governor Pierpont turned around and removed Mayo as mayor, and General Alfred Terry, a more moderate army officer, assumed command of Richmond's occupying forces.

A sit-in on streetcars took place on April 11, 1867. In Charleston, South Carolina, African Americans had successfully challenged segregated

streetcars. Richmond citizens did the same thing. Three men purchased tickets with the express intention of sitting in the whites-only seating area. The community anticipated a response to expected arrests. By the time the second man was arrested, hundreds acted to protest the arrest. It is not clear if the ban was temporarily lifted. But the Virginia Republican Party did not maintain its support of African-American issues for long. African-American militia units organized and paraded during this period to show their pride and self-fulfillment. Members of the Lincoln Mounted Guard unit attempted to ride any streetcar and were arrested. Clearly, following a few weeks of more arrests, the streetcars became permanently segregated.

African-American families and individuals had led an active church life in antebellum Richmond. They did this again after the war, but in a more open way. Churches and trades formed secret societies for mutual benefit before the war and now did so again. Now African-American churches had African-American pastors. Underneath all of this activity was an implicit constraint on freedmen and women. If they worked as domestics, barbers, caterers or hack drivers, or if they depended on white patronage for their livelihood, they did not participate openly in any form of demonstration or activism. But all these efforts collectively planted the seeds of African-American internal support of their community.

The key to understanding Richmond is that the original government of our nation following independence was overthrown in 1861, then the Confederate form of government was also overthrown in 1865. All beliefs and certainties were thrown into disarray. Religion stood as the single solid pillar of certainty for most people. When the structures of slavery fell along with the Confederacy, there was simply no belief system to take its place. Between the dictates issued by Congress that required a new constitution and reapplication for admission to the union and local politics, there were gaps and dissatisfactions. In the spring of 1869, Gilbert Walker, a conservative Republican acceptable to Democrats, was elected governor of Virginia. Walker appointed a new city council, which selected Henry Ellyson as mayor. The current mayor, George Chahoon, a young radical from New York, refused to vacate the office. Followers of Ellyson surrounded a police station, where Chahoon made a stand. General E.R.S. Canby, acting without authority, sent three companies of troops from Camp Grant to rescue Chahoon. This situation ended in a lawsuit, to be heard on April 27, 1870, in the Virginia Supreme Court of Appeals in chambers on the top floor of the capitol. Just as proceedings were to begin, a cracking sound was heard; the upper floor gave way, crashing into the lower floor, which subsequently

caved in on the House of Delegates, which at that time was empty. As a result, 62 people lost their lives, including the grandson of Patrick Henry, Patrick Henry Aylett. Another 251 sustained injuries. The cause was the addition of a floor to create more offices that was not properly designed. Wisely, the decision to restore the capitol prevailed. A few days later, the court rendered a ruling favorable to Ellyson.

In 1869, the stone pyramid dedicated to the Confederate dead was erected in Hollywood Cemetery, which became the primary cemetery of the city, since it held so many who had died during the war. In the summer of 1870, a drought gripped Virginia, followed by significant rainfall that caused the James River to rise, washing out the Mayo Bridge again and flooding lower Main Street between Fifteenth and Seventh Streets. Similar flooding in low-lying areas occurred several more times until a floor wall was finally completed in 1996. After the 1870 flood, the other major floods occurred in 1936, 1937, 1969, 1972 and 1985.

This chapter of Richmond's history closed on October 12, 1870, when Robert E. Lee died. His death reminded citizens of the depth of their losses. The Spotswood Hotel burned on Christmas Eve and marked the end of a year of significant losses and destruction.

5

RICHMOND REBUILDS AND SURVIVES TWO FINANCIAL PANICS

The travail of freedom and justice is not easy, but nothing serious and important in life is easy. The history of humanity has been a continuing struggle against temptation and tyranny—and very little worthwhile has ever been achieved without pain.
—Robert Kennedy

PROSPERITY AND GROWTH

In the 1840s, Richmond ranked as a major industrial city in the South. It had fifty-two tobacco factories and seventy-seven iron foundries, plus all the businesses aligned with them as customers or suppliers, such as paper and printing for tobacco, as well as machine shops, forges and rolling mills that used iron. These industries required a lot of labor. Owners supplemented their workforce with enslaved persons—men, women and children. As Joseph R. Anderson ramped up Tredegar Iron Works before the war, he contracted with slave owners for workers. This early industrialization was funded by northern investors and employed some German and Irish immigrants who lived in the Jackson Ward area primarily. Northern financial interests therefore benefited from the work of enslaved persons before the war. The same kinds of investors returned to Richmond after hostilities ended.

The same basic industries went back to work as quickly as they could. The economic activities of Richmond experienced a continuously upward

trajectory after the war. Political tensions did not derail rebuilding and recovery efforts. In 1867, Richmond annexed two and a half square miles of Henrico County, doubling the size of the city. This action necessitated adding two new voting wards, raising the number of wards to five. In 1870, the voting population was evenly split between the races—6,868 whites and 6,220 African Americans—mainly due to the disfranchisement of former Confederates who had not taken the Loyalty Oath. In 1871, the conservative faction gained control of city government and created a new sixth ward whose boundaries were carefully drawn to include most of the African-American population. From this point forward, an African-American majority could elect representatives to city council from the new Jackson Ward only. This high-water mark of African-American voting power would not be reached again until decades in the future.

When July 4, 1871, rolled around, Richmond held its first-large scale Fourth of July celebration since the surrender. (Vicksburg, Tennessee, after its surrender to General Grant on July 4, 1863, did not celebrate Independence Day again until 1945.) But Richmond was rebuilding everywhere. Even with an impoverished tax base, the city made remarkable progress. The horse-drawn trolley was extended, bridges rebuilt, a new state constitution put in place and a public school system established. Richmond was expanding water, gaslight and fire protection services, as well as the police force.

Some industries could not make the transition to a large-scale economy and national markets. The resources of coal and iron ore were not of sufficient quality to expand those industries beyond regional markets. Northern investors found their way to Richmond. The James River, besides its natural limitations, silted too easily. As a result, railways became the dominate mode of transportation.

Richmond's commercial district had been rebuilt with iron-front architecture, allowing more glass storefronts. It gave the city an up-to-date appearance. Memories of the war, however, lingered. Every Memorial Day, women dressed in black walked the rows in the cemeteries. Proportionally, those in the former Confederate states suffered more than communities that had remained in the union. On April 21, 1873, the Haxall-Crenshaw flour mill burned, but it was later rebuilt. In addition to Gallego and Haxall, Dunlop Mills was the largest miller in the nation until 1866, when a larger facility was constructed in Minneapolis, Minnesota. Dunlop Mills produced from 1853 until 1949. Operations depended only on waterpower. While it was slightly damaged during the Evacuation Fire, it quickly returned to production. The need for the consumer staples of flour and chewing tobacco

plugs provided a stable manufacturing base. Soon, the advent of cigarettes would diminish the demand for plug tobacco.

In 1870, Richmond-area coal mines produced sixty thousand tons of coal. However, coal of a higher quality was discovered in Tazewell County in 1873. The transcontinental railroad was completed in 1869. It not only transformed the western United States, but it also showed that railroads could create national markets. Richmond coal declined and ceased production in 1904. But other industries started. Trains became a big business, first by transporting construction materials to rebuild the city and then by its usefulness to various manufacturers.

The inclusion of African Americans varied at almost every level of political, social and economic activity. Confederate general George Picket died in 1875 in Norfolk. He was buried at Hollywood Cemetery, and African-American militia units participated in the procession. But their request to participate in a parade to unveil Stonewall Jackson's statue at Capitol Square produced an uproar by former Confederates. Governor James L. Kemper said their participation in the parade had received prior approval and they would not be excluded, but for some unknown reason, the units did not show up. It has been estimated that upward of fifty thousand people participated in the ceremony. One speaker that day was Bishop James Gibbons of North Carolina, who helped found the Little Sisters of the Poor before going on to become archbishop of Baltimore in 1877.

The Richmond Colored Normal School, established by the Freedmen's Bureau, expanded in 1873 to a larger facility, where it trained teachers. From 1869 to 1900, the city built four schools to serve African-American students. Schools for white students were stretched to capacity as well during this time. There simply was not enough funding to meet the needs.

According to Lewis A. Randolph and Gayle T. Tate, "Mutual benevolent societies, fraternal orders, social organizations, and incipient labor and political unions served as the social and economic ancillaries of the black church." African Americans, because of their shared experiences, relied on one another—family, church friends and work associates. Their associations were labeled "secret societies" because they grew out of more clandestine activities in the antebellum era, but they were simply mutual benefit societies, like insurance companies. Here, members and participants learned organizational and financial skills. There were more than four hundred of these groups helping members who fell into need—widows, orphans, elderly, sick and injured persons—since charitable organizations were few. They helped keep the

community safe and secure in other ways, as well. "Political societies were vital to sustaining the freedom of the African-American community by placing the community's political grievances before the Richmond City Council, the Virginia General Assembly, and the Republican party." By 1870, the Freedman's Bank already had $318,913 on deposit, and African Americans owned nearly $1,000,000 in real estate, more than any other Virginia city.

THE PANIC OF 1873

The entire nation experienced an economic boom after the Civil War ended. There were multiple causes for the ensuing depression, but the trigger event was the failure of Jay Cooke and Company, the principal backer of the Northern Pacific Railroad. The nation over-expanded the construction of new railroads. The government had no experience dealing with catastrophic economic events. The Panic of 1873 that gripped the nation impacted the city, but since the South as a whole had lower average income, the impact was perhaps not as severe. The depression caused by the panic lingered until about 1880. For example, in 1877, for each opening in the police department, the city received 175 applications.

The value of agricultural products plummeted. Cotton prices fell by almost half, so that cotton sold for barely more than the cost to produce it. Tobacco farmers were just recovering from the war when prices collapsed. Tredegar Iron Works, due to nonpayment from its railroad customers, went into receivership, reemerging only in 1879. All the savings of African Americans with the Freedman's Bank were wiped out. No one was spared this new round of hardship. Overall, the 1870s, after the depression started, was a time when average people focused on getting by. Plus, much time and effort was required to keep households going. Washing, ironing, fixing meals, cleaning and repairing—things that today take little time—consumed the days and nights of couples working and raising children, no matter their race.

The life of workers, domestic help and businessmen fell into patterns during these years. African-American women worked mainly as domestic workers or in the tobacco industry. African-American men worked in a wide variety of occupations, including artisans, laborers, factory workers, barbers, bakers and hack drivers. White women did not usually work. White

men had the widest options for meaningful work, including as journalists, printers, bankers, as well as factory and construction workers. At noon, the average business or professional person went home for "dinner." There was no electricity yet, and gaslight was not widely used. It made sense to eat the big meal of the day when there was natural light. Everyone did a lot of walking, especially those who could not afford the horse-drawn streetcar. There were not many places to pick up lunch, so most workers carried their lunch with them. But there were street vendors called "cake men" who called on businesses, and there were 163 saloons around the city according to a count in 1883.

Richmond business enterprises began to change in the late 1870s and early 1880s. The flour mills began to lose markets in South America as those areas became better at producing wheat and milling flour. Richmond Cedar Works and Richmond Chemical Works began alongside the start of C.F. Sauer and Company. The Valentine family started a company in 1871 that sold beef extract. It became a product sold all over the world. Valentine's Meat Juice was in such high demand that a new plant began operation in 1876.

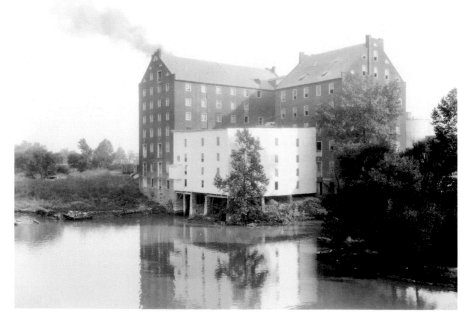

Dunlop flour mill, south Richmond (no date). *Library of Congress.*

But the biggest impact to the Richmond economy occurred with the introduction and production of cigarettes. Lewis Ginter had been a successful businessman before and after the war until he lost his wealth while in New York in the Panic of 1873. He then joined John F. Allen to form Allen & Ginter Tobacco. Ginter was a marketing genius, and the firm made cigarettes rolled by women in Richmond and sold around the world. The firm grew phenomenally with the invention of the Bonsack mechanical cigarette roller. Eventually, Allen retired. Ginter merged his firm with James B. Duke's American Tobacco Company. Ginter was a very wealthy man for his times, and he shared that wealth in Richmond. He donated land to Union Theological Seminary in 1898 and enabled the creation of the Lewis B. Ginter Botanical Gardens by his niece Grace Arents. Ginter had served in the Confederate army, rising to rank of major, a title he used the remainder of his life. Ginter was probably gay and lived with his partner, John Pope, who died possibly from tobacco usage a year before Ginter. They lived together as business partners and kept a low profile. Ginter spearheaded

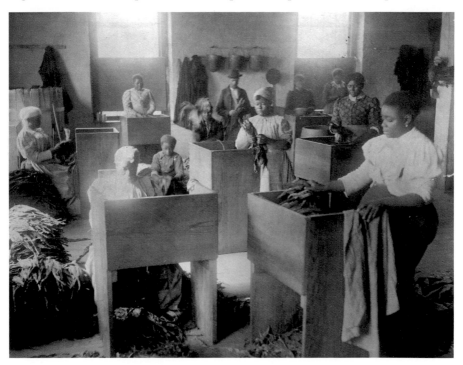

African American women sorting tobacco at T.C. Williams & Company, circa 1899. *Library of Congress*.

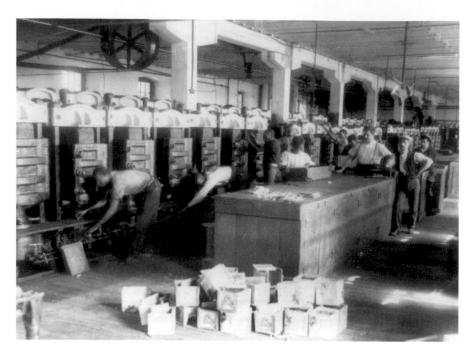

Box making in the T.C. Williams & Company tobacco factory, Richmond, c. 1899. *Library of Congress.*

the construction of the Jefferson Hotel. In 1888, cigarette manufacturing employed more than one thousand workers and was producing more than two million units a day. His marketing skills created a significant cigarette industry in Richmond, and his philanthropy, coupled with that of Grace Arents, makes him one of the most important private citizens in the history of Richmond.

The Southern Historical Society formed in New Orleans in 1868 to preserve and present viewpoints of the Confederacy. The society moved to Richmond when former general Jubal Early secured free space for it in the state capitol building in 1873. Subsequently, William Jones, a Baptist minister, as secretary-treasurer of the society steered all publications to identify the Civil War as a struggle over states' rights, though he allowed a wide range of opinion on battle tactics. This organization established Richmond as the source of the concept of the "Lost Cause" and the center of Confederate commemoration, monuments and memory.

In 1877, the Richmond Stove Works began operations at Twenty-Fifth and Main Streets. The stoves were renowned for their high quality and

found markets as far north as New York and Philadelphia. This was how people cooked in those days, and the company made several models to fit the needs of the markets it served. In 1888, it even created the Lee Stove, which appealed to the Lost Cause as well as being a sturdy product! The availability of gas and electricity supplanted this market in the 1920s.

RICHMOND EXPANDS

Richmond's appearance began to change in the last decade of the nineteenth century. The erection of the Lee Monument in 1890 (at Monument Avenue and Allen Street) on land that had been cow pasture marked an important expansion of the city. Several competitions for the design took place. The statue was finally awarded to Antonin Mercié, who cast Lee riding a horse (but not Traveller, as most believe). The statue was shipped in pieces, assembled here and pulled on four wagons by 10,000 people according to newspaper accounts. On May 29, 1890, crowds were estimated at 100,000 to view the unveiling of the first monument, to Robert E. Lee, on the avenue that often defines Richmond.

In 1887, the city council authorized the Richmond Union Passenger Railway Company to create an electric trolley system to replace the horse-drawn system. A New York engineer, Frank Sprague, promoted the idea and oversaw the completion of the first large-scale electric streetcar system. In 1888, the system went into operation using a trolley attached to an electric overhead wire that propelled the four-wheeled cars. A large generation plant was built to supply the electricity. Initially, this system covered just over twelve miles from Church Hill to the new Reservoir Park, as Byrd Park was called then. With the advent of trolleys, Richmond could be expanded. Lewis Ginter bought large tracts of land north of the city and laid out Ginter Park. He operated his own trolley car system to serve the area.

In 1887, the Richmond Locomotive Works organized. During forty years of operation, it produced upward of 4,500 engines. It was the largest and most significant manufacturer of locomotives in Virginia during its years of production. Its only contemporary in Virginia was the Roanoke Shops, which produced locomotives exclusively for Norfolk & Western. In 1901, the works merged with several others to form the American Locomotive Company, which continued production at the Richmond works until 1927. A piece of the remaining factory was converted into Bowtie Cinemas.

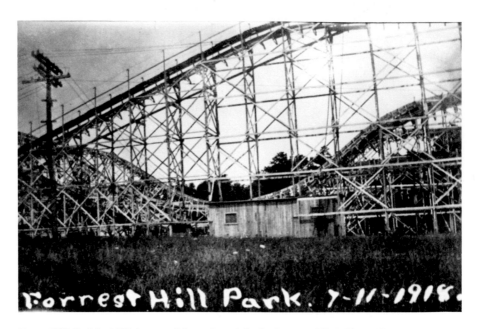

Forest Hill Park in 1918 (scanned from the original). *Courtesy of Jack Trammell.*

Memories of the war also drove changes in the Richmond landscape. In 1883, Channing Robinson sold his family's farmhouse and thirty-six surrounding acres to establish a Confederate soldiers' home. On April 18, 1883, a group of concerned Confederate veterans met in Richmond to establish the Camp Lee Soldiers' Home as a benevolent society for poor and infirm Confederate veterans. The R.E. Lee Camp No. 1 occupied the property that is today the grounds of the Virginia Museum of Fine Arts from 1885 to 1941. The former White House of the Confederacy had been used as a school but, in 1896, became a museum. Libby Prison was dismantled and then displayed at the Chicago World's Fair, but it was never returned to Richmond. The house Lee had occupied at 707 East Franklin Street was donated to the Virginia Historical Society in 1893. The body of Jefferson Davis, who died in New Orleans in 1889, was brought to Richmond in 1893 to be re-interred in Hollywood Cemetery. It was another occasion for large crowds to commemorate the memory of the Civil War.

Other leaders from the war years also began to make their marks. Joseph Bryan, a member of Mosby's Rangers, studied law at the University of Virginia and then settled in Richmond. He partnered with John Stewart, his father-in-law, and several other prominent Richmonders in a variety of business ventures. He partnered with William R. Trigg to transform

Battle Axe Shoe Company, Broad Street. Haines Photo Company, circa 1909. *Library of Congress.*

Confederate Soldiers' Home, Richmond, Virginia, by Detroit Publishing Company, circa 1908. *Library of Congress.*

the Tanner & Delaney Machine Works into the Richmond Locomotive Works, a portion of which was converted into Bowtie Cinemas on the Boulevard. Lewis Ginter dropped the struggling *Times* newspaper onto Bryan in 1887. Bryan transformed the *Times* into a worthy competitor of the *Dispatch*, Richmond's leading newspaper. But one of Bryan's greatest

contributions was from the strength of his character. In 1893, he refused a duel with Jefferson D. Wallace, effectively ending the idea of dueling to settle arguments. Over the years, many lives had been lost to what he called a "barbarous and absurd" endeavor. Another Confederate, Major James H. Dooley, accumulated a fortune from railroads, real estate and steel. He used his wealth to acquire and build Maymont in 1890. The estate passed to the city at the death of Mrs. Dooley.

In 1893, another financial crisis hit the nation and Richmond, but there was enough economic momentum that it did not cause as much disruption as the previous depression had. Jane King established a successful ice business, bringing in ice from Maine. Velva A. Lockwood was the first Richmond woman to be issued a license to practice law, in 1894. Many beneficial developments occurred in Richmond in the last decade of the nineteenth century. Richmond College elected a twenty-seven-year-old faculty member, Frederic W. Boatwright, as president, who moved the institution forward on many levels. Union Theological Seminary moved from Hampden-Sydney College to Richmond in 1898.

Granite quarries abound in the area along the James River. Stone from these quarries was shipped to St. Louis to build the piers of the first great bridge to span the Mississippi. The quarries were also used to provide stone for the erection of the former State, War and Navy Buildings, built between 1871 and 1888 in Washington, D.C., that adjoin the White House grounds and today house the Executive Office of the President at Pennsylvania Avenue and Seventeenth Street. Granite from the nearby quarries was used in the building of the steps and approach to the State Capitol, some downtown churches and the Confederate Soldiers and Sailors Monument on Libby Hill (next to Church Hill). Also, granite used to construct Old City Hall (completed in 1894) at 1001 East Broad Street came from local quarries. The buildings on the VUU campus, opened in 1899 for classes, were constituted with the same granite in the Gothic Revival style.

JIM CROW RICHMOND, 1870–1900

Across the South, many laws were enacted restricting the rights of African Americans. Laws mandating a segregated society were generally called "Jim Crow" laws. Richmond, no worse than other municipalities in the South, participated in both creating a segregated society and reducing the voting rights of African Americans. The topic is too broad to deal with here. Suffice

Old City Hall. *Photo by Kimberly Hise Photography.*

it to say that even though Virginia approved the Fourteenth Amendment to the Constitution as part of its re-admittance to the union and to be able to send representatives to Congress, it found ways to gradually restrict and basically eliminate the participation of African Americans in the political process. For many years, a notable spotlight on the situation was cast by John Mitchell Jr., the editor, beginning at age twenty-one in 1884, of the *Richmond Planet*. Between 1880 and 1894, there were sixty-one hangings across Virginia. Mitchell received more than his share of threats. He denounced segregation consistently in his paper. The irony of Jim Crow laws was stated acerbically by Mitchell: "Jim Crow beds are more necessary in the Southland than Jim Crow cars…and…white men who so anxious to be separated from colored men must also be made to separate from colored women." The city for its part continually redistricted the various wards to thin out African-American voters and make registration hard. The final nail in the coffin was the Constitution of Virginia of 1902, which effectively disfranchised African Americans from voting.

6

RICHMOND BEGINS TO FLOWER

History is not a burden on the memory but an illumination of the soul.
—Lord Acton

Perhaps the most important thing to keep in mind about this period as Richmond moved into a new century is that leaders of both the African American and white communities most likely were in their forties and fifties—the height of their abilities and achievements. But they had been very strongly influenced by the Civil War. Most African American citizens of Richmond at the turn of the century had been born enslaved, or their parents may have been enslaved. For white residents, the belief in a "lost cause" and its hold on them influenced their actions. It was a deeply segregated society. That was the setting as Richmond entered the twentieth century.

Jackson Ward

Jackson Ward was the strong thread across the African-American community that held it together in Richmond from 1870. The area that would become known as Jackson Ward was first inhabited by people of Italian, Jewish and German descent. In the mid-1800s, free and enslaved African Americans moved into the community. The area north of Broad

Street was joined with recently annexed territory from Henrico County. Because African Americans could not go to the same theaters, hotels and stores as whites, an African-American community evolved that included a vibrant, self-sufficient economy, including banks, barbershops, restaurants, benevolent organizations, insurance companies and medical practices. Influential figures such as John Mitchell Jr., editor of the *Richmond Planet*, an African-American newspaper, and Maggie L. Walker, the first woman to charter and serve as president of an American bank, operated businesses and lived in Jackson Ward. In 1902, George Mitchell founded the Mechanic Savings Bank; Maggie Walker established the St. Luke Penny Savings Bank in 1903.

Central to the community's social and economic life was Second Street, also known as "The Deuce." Wayne Dementi and Brooks Smith put a book together called *Facts and Legends of the Hills of Richmond*, which is a love story devoted to Richmond. In it, the authors discuss Jackson Ward and confirm what many online sources tell us: Jackson Ward was *the* place to go for young, hip black men and women in the 1920s. Just as Harlem was the center for black art and music in 1920s New York, Jackson Ward

Leigh Street Houses, Jackson Ward Historic District (no date). *Library of Congress.*

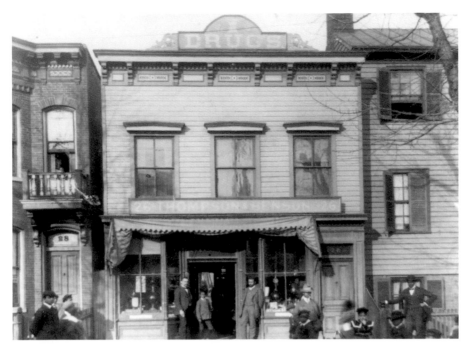

Above: Thompson & Benson, Leigh Street Pharmacy, 1899. *Library of Congress.*

Left: Richmond Dairy, Jackson Ward, apartments, 2017. *Courtesy of Guy Terrell.*

was the same for Virginia. If Harlem had the Cotton Club, the Stork Club and the Silver Slipper, Richmond had Happy Land, Top Hat and Shorties. Many entertainers performed at the Hippodrome Theater, including Ella Fitzgerald, Duke Ellington, Cab Calloway, Lena Horne and Bill "Bojangles" Robinson. Jackson Ward was nicknamed "The Harlem of the South," a tribute to its prominent social and economic status. Jackson Ward proved that the human spirit and high achievement could be segregated by the ruling council but could not be snuffed out. Richmond showcased its own talent, too. One group in the 1920s consisted of members of Roy Johnson's Happy Pals, a swing orchestra. The ten Richmond natives—Jackson Ward natives, in fact—beat out Duke Ellington's orchestra in a 1929 New York band contest. You can prevent a man or woman from voting, but you can't stop them snapping their fingers and laughing.

Virginia Union University Gets a Permanent Home

In 1899, it was agreed that Wayland Seminary, a special college for the exclusive education of African-American women founded in 1883, and Richmond Theological Seminary would come together to form Virginia Union University (VUU). At the intersection of Brook Road and Lombardy Street, the distinctive late Victorian Romanesque Revival–style building of Virginia granite designed by John Cohead of Buffalo, New York remains today the core of the university. The Belgian Friendship Building, with its unique tower, was donated to the university after the 1938 World's Fair, since it could not be shipped back to Belgium due to the outbreak of World War II. Notable graduates are too numerous to exhaustively list, but some, such as Booker T. Washington, who graduated from the Wayland School and then Hampton University, deserve mention. In 1952, VUU graduate Simeon Booker became the first African-American reporter for the *Washington Post*. More recent notable graduates include L. Douglas Wilder, the first African-American governor of Virginia; Henry L. Marsh, the first African-American mayor of Richmond; and Spottswood Robinson III, prominent civil rights attorney and, later, dean of Howard University Law School.

Belgian Friendship Building (bell tower), gift to VUU after World's Fair, 1941. *Photo by Misti Nolen.*

Belgian Friendship Building cornerstone, gift to VUU, 1941. *Photo by Misti Nolen.*

In North America, only Native Americans and southerners have ever "lost" a war and then been monitored by the victors. In the South after the war, attitudes and a culture of segregation grew out of this experience. The destruction, death and loss of the only way of life most had ever known caused southern states opposed to amendments to the Constitution granting former slaves new rights to create other ways to restrict the movements, rights and living areas of those newly freed persons. Out of that milieu grew the stories of the Lost Cause. Myths about the war look hold. Every year, parades were held by former Confederate soldiers in the old capital of the Confederacy. Monuments to generals were installed on Monument Avenue, starting with Robert E. Lee's statue in 1890. In 1907, the statues of J.E.B. Stuart and Jefferson Davis were unveiled at roughly the same time. The unveilings coincided with the largest Confederate reunion ever recorded, when eighteen thousand veterans attended. The papers were filled with stories about these events. The last Confederate monument installed honored Stonewall Jackson in 1919. Richmond was saturated with memories of the Civil War. The last Confederate veterans reunion took place in 1932. Richmond celebrated the memory of the Civil War for sixty-seven years! During that time, the memory of the Lost Cause became institutionalized in the city.

At the same time, African Americans held Emancipation Day parades. A famous photo taken on April 3, 1905, shows many marchers parading at Tenth and Main Streets, with the Shafer Building at the corner and the old Custom House and Richmond Post Office building in the background. To the right of the post office is the Mutual Assurance Society Building. The parade marked the fall of Richmond, the de facto date when slavery ceased in the city, but not the anniversary of the Emancipation Proclamation. In 1903, the city completed the disfranchisement of African Americans by eliminating Jackson Ward as a political entity.

Ideas can be likened to very small businesses looking for "customers." The acceptance and support of segregation slowly changed in Richmond, and elsewhere across the nation, in the twentieth century as more people came to accept the idea that such a system, along with the denial of basic rights, was wrong. Ideas and beliefs about segregation gradually lost their customer base as the old Confederates literally died off and African Americans began to demand more rights. This is the undercurrent of Richmond's history in the last one hundred years.

RICHMOND, 1900

Marie Tyler-McGraw, in her book *At the Falls*, relates the story of a man, Louis Powell, who came to Richmond at the turn of the century, when many others also started to leave the rural life behind. He came to attend business school. "Others came to study law, work on the docks, or become live-in maids, schoolteachers, typists, or telephone operators. Except in the hardest of hard times, rural Virginians came to Richmond steadily, especially in the early part of the twentieth century. They brought with them a resupply of rural values, beliefs, and pastimes that kept Richmond from drawing too far from the countryside." Country families had always been large in order to supply labor on the family farm. James Franklin Terrell, the author's grandfather, had six children who survived. In the 1920s, his children came to Richmond to find work. One even opened a garage downtown. The girls lived in boardinghouses until they found work. Older brothers, once they were established, paid for training for siblings in new professions. Children needed to leave the family farm due to better opportunities in the city. Newcomers to the city gave relatives a helping hand to join them in

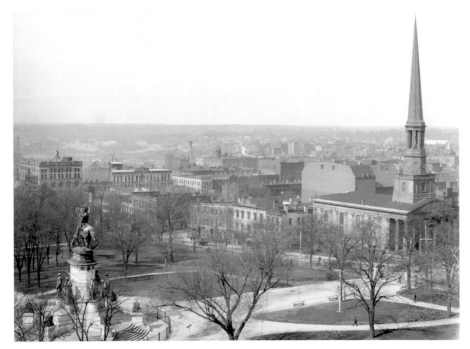

Richmond from Capitol Square, 1905. *Library of Congress.*

Emancipation Day parade, April 1905. Photo by Detroit Publishing Company. *Library of Congress.*

Richmond and other cities. Migrants to the city in the 1920s, such as the Terrells, were born in the first decade of the twentieth century. My Aunt Hilda came to Richmond, worked at Western Union and met her husband, Guy Clarke. This is but one example of trends that started after the Civil War and peaked in the first half of the twentieth century.

Every newcomer had a story and a driving force that brought them to Richmond and provided the impetus to stay. Marie Tyler-McGraw said, "By the late nineteenth century, many of these migrants were single women. Women who worked on isolated family farms without pay and without prospect of inheritance viewed the hard labor of factories as a decided improvement in their circumstances." The city offered retail stores, the company of others their age, more marriageable men, theaters and dance halls.

Evidence of growth was abundant. On June 2, 1900, the first train from Tampa, Florida, pulled along Seaboard Airline Railroad tracks by two locomotives built by the Richmond Locomotive Works, entered Richmond

via a newly completed bridge over the James River. The event was accompanied by shots fired from howitzers near the station, and the young son of the president of the railroad, John Skelton Jr., drove a golden spike to signal the railroad's completion.

The Jefferson Hotel burned in March 1901. An asset to the business and social life of the city, it survives today due to the determination of various owners to maintain the opulent structure. Following the blaze, Henry Lee Valentine organized a group of one hundred persons, who carried out everything of value they could, including Edward V. Valentine's statue of Thomas Jefferson. But it was not until 1907 that the hotel resumed full operation.

Another important event took place when the *Dispatch* newspaper, owned by John L. Williams & Sons, was purchased by Joseph Bryan and combined with his paper to form the *Times-Dispatch*. At the same time, Bryan sold his *News* to John L. Williams & Sons, who merged it with Williams's other paper

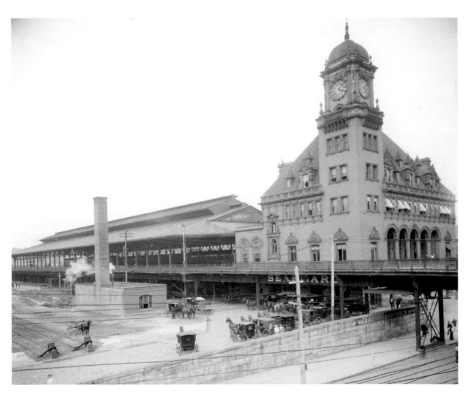

Main Street Station between 1900 and 1910. Photo by Detroit Publishing Company. *Library of Congress*.

The Murphy Hotel Richmond, circa 1915. *Library of Congress.*

to form the afternoon daily the *News Leader*. In 1909, John Stewart Bryan bought the *News Leader*; the newspapers that dominated Richmond for most of the twentieth century were put in place. Joseph Bryan died in 1908, and his wife donated two hundred acres to the city for a park to memorialize

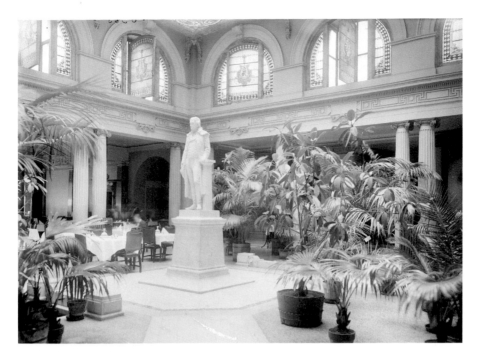

Jefferson Hotel Palm Garden with statue of Jefferson, 1908. *Library of Congress.*

him. Bryan Park, dominated by enormous old trees, can be entered today from Lakeside Avenue.

The Commonwealth of Virginia adopted a new state constitution in 1902. According to an *Encyclopedia of Virginia* article by Susan Breitzer, it stands as an important example of post-Reconstruction efforts to restore white supremacy in Virginia by disenfranchising large numbers of African Americans and working-class whites. It remained in effect until July 1, 1971, doing much to shape Virginia politics in the twentieth century—a politics dominated by a conservative Democratic Party that fiercely resisted the New Deal, the New Frontier, the Great Society, the civil rights movement and, with special fervor, federally mandated public school desegregation. In 1896, there were 2,983 African-American voters registered in Jackson Ward and 789 white voters. After the new constitution took effect, there were only 33 African-American voters who could register there. The constitution stipulated that sons of veterans could register to vote; however, Attorney General William A. Anderson ruled that illegitimate African Americans were not eligible to vote, even if they could prove that their fathers were Confederates.

John Mitchell Jr. edited and published the *Richmond Planet* newspaper from one year after its founding in 1883 until his death in 1929. His career, life and efforts exemplify the type of city Richmond was for African Americans. Born in 1863 to slaves in Henrico County, Mitchell graduated high school at the top of his class in 1881. He taught in Virginia Public Schools until state politics led to the firing of many black teachers, including him. He and some other teachers rescued the *Planet*. In 1895, three African-American women were charged with the murder of a white woman based solely on the testimony of a witness who changed his story several times. The prosecution eventually dropped the charges, and even the white press acknowledged the *Planet*'s role in the outcome.

Mitchell organized a boycott of the streetcars in Richmond to protest segregation in 1904. Due to the African-American boycott and a strike by its motormen and conductors, the company declared bankruptcy. A new company, the Virginia Railway & Power Company, took over and decided in 1906 to make segregation mandatory. African Americans made many individual strides during these years, but there was nothing to show across the broad spectrum of civil rights.

PHILANTHROPY

In 1906, the Cathedral of the Sacred Heart was dedicated. The cornerstone, cut from a solid rock from the Mount of Olives, had been laid three years before. Construction was made possible by a single gift of $500,000 from Thomas Fortune Ryan, a Virginia-born New York businessman, and his wife, Ida Barry Ryan. The cathedral is Virginia's finest ecclesiastical example of the Italian Renaissance Revival style, constructed with Virginia granite and Indiana limestone covered by a copper dome and tile roof. Six fluted Corinthian columns support the architrave on the front of the exterior, which displays the motto "If Ye Love Me Keep My Commandments" (John 14:15). The outline of the coat of arms of the Diocese of Richmond appears above the name of the church to the left of the columns. The cathedral holds frequent programs open to the public. First-time visitors leave inspired.

The city acquired the West End Market at the 900 block of West Cary Street in 1890. It provided a large enough stage to bring many concerts and large gatherings to Richmond. It was known as the City Auditorium. Today, it is a gymnasium on the campus of VCU. Nearby is Saint Andrews

Elementary School at 227 South Cherry Street, founded in 1894 and donated by Grace Arents, niece of Lewis Ginter, to serve low-income families. The buildings, also Gothic Revival, were completed about 1900.

Healthcare made significant improvements about this time through the efforts of Dr. Ennion G. Williams, who worked to eradicate malaria, fight typhoid fever and generally improve sanitary conditions in public schools. Sadie Cabaniss, Agnes Randolph and Nannie Minor worked among the poor, and they all later served in the Instructive Visiting Nurse Association (IVNA). The IVNA was the first organization to provide home nursing visits to those not allowed in the traditional hospital setting due to race or income.

The Association for the Preservation of Virginia Antiquities saved the "Old Stone House" (1914 East Main Street), which was about to be pulled down in 1912, from destruction. The oldest building in Richmond later became the Edgar Allan Poe Museum. They leased the John Marshall House in 1911 to preserve it.

RICHMOND AND MANCHESTER MERGE

The James River separated Richmond on the north from the independent city of Manchester on the south. A major issue for Manchester and Richmond residents in the nineteenth and early twentieth centuries were toll bridges over the James River. In 1910, Manchester agreed to a political consolidation with the much larger city of Richmond. Richmond's better-known name was used for both areas, as it is Virginia's state capital. Key features of the consolidation agreement were requirements that a "free bridge" across the James River and a separate courthouse in Manchester be maintained indefinitely. Instead of a barrier between neighboring cities, under the consolidation, the James River became the centerpiece of the expanded Richmond.

Richmond continued to annex nearby areas. By 1914, the city consisted of nearly twenty-three square miles and 145,000 residents. Commercial shopping expanded south of Broad Street. Many saloons operated on the north side of Broad. A few Model T Fords could be found in Richmond in 1907; by 1913, there were fewer than two hundred privately owned automobiles registered. From 1913 to 1923, the Kline Kar was produced in Richmond. It was a more expensive, heavier car with a very limited market.

The city was progressive and forward looking in many respects. The city installed better water filtration in 1909. Families were used to obtaining clean, clear drinking water from springs, since water from the James River made city water consistently muddy. In 1901, based on what New Orleans, Louisiana, and Mobile, Alabama, had done, city commercial interests organized a carnival to promote commercial aspects of the city. An archway resembling the Eiffel Tower was located in the center of Broad Street, edged with lines of incandescent lights and topped by a star-shaped cluster of lamps. Much of the lighting was provided by electric railway headlights. There were parades and floats. It became the precursor to the Tobacco Festival Parade and potentially all the current festivals that occur in Richmond each year. In 1914, Richmond was selected as the site of the Fifth District Federal Reserve Bank.

The expanding income of most citizens created many new entertainment venues. The theater mogul Jake Wells built many vaudeville theaters and opera houses in Richmond in the early twentieth century. Other theaters and opera houses opened on what became

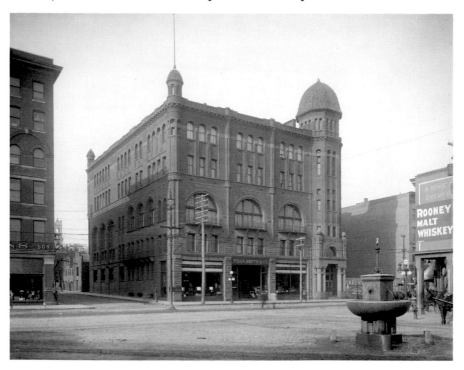

Masonic Temple between 1910 and 1920. Photo by Detroit Publishing Company. *Library of Congress.*

"Theater Row," including the Colonial Theater (the façade survives as the entrance to the Department of Social Services) and the Lyric Opera House (demolished) along Broad Street. African Americans went to theaters and clubs in "The Deuce."

World War I

Richmond benefited directly from World War I with the creation of Fort Lee in Petersburg and the ancillary services needed to support it. Several factories converted to the manufacture of shells and powder. It brought new levels of prosperity to the city, even though the United States did not enter the war until 1917. On the other side of the world, in Russia, a locomotive produced by the Richmond Locomotive Works and sold to the Finnish State Railways pulled Lenin's train into St. Petersburg on the last leg of his return from exile during the Russian Revolution of 1917. The increase in troop movements boosted usage of Broad Street Station (now the Science Museum of Virginia), completed in 1917 as the terminus station of the Richmond, Fredericksburg & Potomac Railroad. Unfortunately, in 1918, the worldwide influenza epidemic broke out at Fort Lee, killing five hundred soldiers. More than eight hundred people in Richmond died from the flu.

7

RICHMOND 1920-1945

The test of our progress is not whether we add more to the abundance of those who have much, it is whether we provide enough for those who have little.
—*Franklin D. Roosevelt*

BOOM TIMES, SWING TIMES

Richmond, like many other cities, felt a sense of optimism after World War I, not only from being on the victorious side but also because there was evidence of growth and prosperity almost everywhere. The city's population doubled between 1900 and 1920 through births, rural migration into the city and the annexation of land from the counties. Philip Morris came to the city in 1919. Trolleys were the primary transportation in the city, although buses would begin to make their appearance by the end of the decade. Broad Street from approximately First Street to Ninth became the primary shopping district, while Main Street was the financial hub. Gradually, the residential streets between the two became commercial. Many young people from rural areas continued to come to Richmond. Usually, older brothers came and then helped younger siblings find a place to live and work.

Richmond had a long tradition of honoring war heroes and putting up monuments to honor them, starting with the George Washington Equestrian Monument erected in Capitol Square in 1858. Richmond demonstrated

Left: Birthplace of Hilda Terrell Clarke in 1902, Lunenburg County. *Courtesy of the Clarke family.*

Below: Hilda Terrell Clarke (*standing, far right*) with friends at Barton Heights Baptist Church before 1958. She left the farm, came to Richmond, worked at Western Union and then married. *Courtesy of the Clarke family.*

the impact of World War I in two notable examples. There were parades and celebrations after the war and plans begun to build a monument to World War I veterans. Confederate reunions provided an opportunity for Richmonders to turn the memory of defeat into celebrations. The victory in World War I meant that local soldiers had again been on the winning side of a war. The city loves heroes. Virginius Dabney relates one of the events best:

> *When, in the succeeding months* [after the end of World War I in 1918], *Richmond's soldiers, sailors and aviators returned from the war, they were feted with parades, speeches and banquets. Marshal Ferdinand Foch, generalissimo of the Allied armies, visited the city on Armistice Day, 1921. He received a welcome such as had seldom been accorded in*

Richmond to any hero. Cannon boomed and virtually the entire population turned out to cheer him as he passed down Broad Street from the railway station to Capitol Square.

Later, the Virginia General Assembly acted to create a World War Memorial Commission and build a lasting memorial to the heroic efforts of Virginia's World War I servicemen and women. The city donated a building site in Byrd Park, and the General Assembly donated funds to build the War Memorial Carillon, which reaches 240 feet high. Dedicated on October 15, 1932, it can be seen above the treetops when driving north on the Powhite Parkway over the James River. When renovated in the early 1970s, the thirty-four bells that played the highest notes were recast into twenty-one new bells with thicker profiles than the originals, producing a better sound. The tower contains a total of fifty-three bells located at 1300 Blanton Avenue, but its height makes it unmissable from any direction as you approach the park. The Arts in the Park festival is held each year on the grounds surrounding the Carillon. Its construction was not an unusual event for a city that had been putting up memorials and memorializing the clash of armies as long as Richmond had.

The Old Pump House in Richmond. *Courtesy of Jack Trammell.*

Many established businesses operated at levels of output higher than those of the prior decade. During these years, the chamber of commerce promoted pride and optimism, claiming in its promotional efforts that Richmond had the largest cigarette factory, cigar factory, woodworking plant, mica mills, baking powder factory and antique furniture reproduction plants in the world. Newer factories in other parts of the country would eventually eclipse these achievements as the nation grew, but evidence of the pride resides in the city's monuments, like a high school whose hallways are lined with trophies of past teams.

Banking and insurance stood out as evidence of other strengths in Richmond's economy. Richmond was selected as the site of the Fifth District Federal Reserve Bank in 1914. The bank was originally located near the federal courts downtown; it moved to a new headquarters building near the capitol in 1922 (today, the Supreme Court of Virginia building) and finally settled at its present location overlooking the James River in 1978.

In 1922, Major James H. Dooley, whose primary wealth came from his railroads, died. He left his home, Maymont, to the city, which would receive the property at the death of Mrs. Dooley. He also left $3 million to the Catholic Sisters of Charity—the largest single bequest to Catholic Charities up to that point. Sisters from the Daughters of Charity out of Maryland had arrived by steamboat at Rocketts Landing to found St. Joseph's Academy and Orphan Asylum for girls at Fourth and Marshall Streets in 1834. The bequest was used to construct St. Joseph's Villa in 1931 at 8000 Brook Road, which at that time was outside the city, to protect children from industrialization and pollution. St. Joseph's Villa is the longest continuously operating children's nonprofit organization in the country.

RICHMOND PUBLIC LIBRARY

"A notable milestone in Richmond's history was the acquisition in 1924 of the city's first free public library," Virginius Dabney wrote. "Richmond was the last city of its size in the country to build and operate such an institution." Andrew Carnegie offered Richmond $100,000 to establish a library in 1901, as he did for many cities across the nation; he was distributing his fortune, but with the stipulation that the city put up $10,000 a year to support it. The city, in its wisdom, declined the offer, saying there were other, more pressing needs. In 1922, a petition signed

by ten thousand citizens for an appropriation of $350,000 for a library went before the city council, which rejected this request as well, saying other public services were more essential. A larger and better organized movement founded the Richmond Library Association. John Stewart Bryan, publisher of the *News Leader*, became president of the organization. In a pattern that established many advances in Richmond's history, other groups and leaders joined the cause. The city council soon approved a $200,000 bond issue in 1924. With these funds, the former Lewis Ginter mansion at Shafer and Franklin, now part of VCU, was purchased for $112,000 to serve as the first Richmond Public Library.

Shortly after the Richmond Public Library opened, Mrs. James H. Dooley (Sallie Mae) died in 1925, leaving $500,000 to the library. The Dooley library opened in 1930 at First and Franklin Streets. A subsequent enlargement of the library between 1967 and 1972 added a two-story addition that wrapped around the original Dooley Library, which is preserved as the Dooley Wing. A branch for African Americans opened in 1925 at 515 North Seventh Street, but the library's full collections and branches were not opened to African Americans until 1947.

Prosperity, Progress and Growth

Richmond flourished in the 1920s. The city's first radio station, known as "Edgeworth Tobacco Radio," began operation in 1925. It was owned by Larus and Brother, a tobacco company known as the House of Edgeworth—the name can still be seen on the tall chimney of one of the converted lofts along Tobacco Row. By 1930, the station broadcast seven days a week, all day. It was the highest-wattage broadcasting station between Washington, D.C., and Atlanta for many years. Pepsi Cola had its headquarters in Richmond from 1923 to 1930, when it went bankrupt and the new owners moved it. The Edgar Allan Poe Museum, at 1914 East Main Street, opened in 1922 in the Old Stone House, built circa 1740. However, Poe neither lived nor wrote in the house, but the house and garden merit a visit. In 1923, a group of farmers formed the Virginia Seed Service, which would be renamed Southern States Cooperative in the 1930s. DuPont purchased land near Bellwood in 1927 for a large rayon and cellophane plant known as the "Spruance Plant." It continues to manufacture there today.

Miraculously, four theaters built in the twenties still survive in their original appearance. In 1923, the National Theater at 708 East Broad opened and, due to dedicated fans and owners, still provides entertainment today. In 1928, the Byrd and Loews Theaters opened as movie houses, both with mighty Wurlitzer organs to accompany silent movies. Loews at 600 East Grace Street today is the Dominion Arts Center with a restored interior. The Byrd on Cary Street continues to show movies and provides organ interludes between shows. It is under long-term refurbishing as funds are available. In 1927, the Shriners opened Acca Temple Shrine near Monroe Park. Financial problems caused them to sell it to the city in 1929. Long known as the "Mosque" for its Moorish décor, many of America's greatest entertainers have appeared on its stage beneath its towering minarets and desert murals. It continues today as a venue for many large productions and was recently renamed the Altria Theater. It, too, had a Wurlitzer theater organ installed. When author Guy Terrell was a child, his neighbor, Harold Warner, died suddenly on February 14, 1961. Harold worked for the telephone company and had received notable recognition for saving the Wurlitzer organ at the Altria Theater by donating his time and making minor repairs. He was working on the organ one night before a meeting of the American Theatre Organ Society. He did not come home that night. He was found in the organ loft, where he had died from a massive heart attack. He was the nightly organist at the Byrd Theater. Eddie Weaver, who played the Loews organ and at the Miller & Rhoads Tearoom, took over at the Byrd after Warner passed away. Warner had saved the organ by donating almost two years of his time and charged only $32.50 for parts. The General Assembly passed a resolution honoring him on March 3, 2015.

Annually, during the World Series, the *Richmond Times-Dispatch* and the *News Leader* rigged real-time baseball diamonds and showed the movement of players as the games progressed. The streets at the newspaper offices were thronged with fans of the game.

The memory of a "lost cause" still had support among the white population of the city. General Jubal Early was instrumental in the relocation of the Southern Historical Society from New Orleans to Richmond in 1873. The myths of the Lost Cause and of the "redeemer" southern nation had their academic bases in the official archive of the society at the state capitol. The organization gradually lost credibility and ceased operations in the early 1950s. But its influence can be found in many older books on the Civil War. Along Monument Avenue, a statue of Stonewall Jackson created by Frederick William Sievers was unveiled in 1919. A monument to Matthew

Fontaine Maury, also by Sievers, was completed in 1929. Sievers, who worked out of Richmond after moving here in 1910, created the Virginia Statue in Gettysburg that launched his career. He created many statues across Virginia commemorating Confederate leaders. The Confederate Memorial Institute, known as Battle Abbey, started construction in 1913 but was not opened until 1919. It is today the home of the Virginia Historical Society at 428 North Boulevard and the Virginia Department of Historic Resources.

VIRGINIA HISTORICAL SOCIETY AND BATTLE ABBEY

In 1946, the Virginia Historical Society (VHS) merged with the Confederate Memorial Association. They were in no way associated with the Southern Historical Society. The main building, which faces the Boulevard, was erected in 1913. Charles Broadway Rouss, a Confederate veteran, donated $100,000, half the cost, toward the construction. The other half came from a payment of $50,000 from the city. The Commonwealth of Virginia donated the land, and small donors across the South provided the rest. The striking entrance, with medallions in bas-relief in the ceiling, set the tone for the memorial. Inside, the most striking feature of the hall is the heroic murals, *The Four Seasons of the Confederacy*, by French artist Charles Hoffbauer. During construction, Hoffbauer returned to France to fight in World War I in 1914 before the murals were finished. He fought on the front lines there. When he returned, claiming to be changed by his war experiences, he felt compelled to wipe out what he had previously completed. He worked tirelessly and zealously to depict Lee, Jackson, Stuart, Mosby and other Confederate commanders, with bugles blowing, cavalry charging, cannons firing and Jackson's ragged "foot cavalry" passing in review before their leader, Jefferson Davis. Thomas F. Ryan paid for the murals. The building was then opened to the public in 1919.

The next addition, in 1921, was Memorial Hall, built to house the archives and the extensive portrait collection donated to the Confederate Memorial Institute (Battle Abbey) by its next-door neighbor, the R.E. Lee Camp, No. 1, Confederate Veterans. Those grounds where the Confederate veterans lived became the site for the Virginia Museum of Fine Arts in 1932.

Once the Virginia Historical Society took over, it began expansion plans. In 1959, new construction enlarged the existing structure to accommodate

more than 3,000,000 manuscripts, more than 200,000 books and thousands of maps. Additions in 1992, 1998 and 2006 greatly increased the size of the building to nearly 200,000 square feet. These changes enabled the VHS to become the Center for Virginia History and offer citizens of the commonwealth a research library, museum exhibitions and other educational programs. There is a diagram on the VHS website showing the additions to the building. The collections and displays at the VHS make it a top destination to experience the history of Richmond, the Commonwealth and the region.

Next door to the VHS at 328 North Boulevard is the white, Georgian marble home of the United Daughters of the Confederacy. Its building, along with the VMFA and VHS, makes this block of property facing the Boulevard bounded by Grove, Kensington and North Sheppard Streets the most valuable block in the city. It represents both the best and worst of our collective history.

The major strides to the city's culture were not mirrored by improvements to the city's human capital. A big reason for the stagnation in opportunities and advances for most citizens was that, from 1924 to 1940, John Fulmer Bright served as mayor of Richmond. As mayor, he believed in limited government and frequently vetoed development projects. He was born in 1877 and likely inherited his belief system of class and human nature during the rise of Jim Crow laws. Later, he opposed federal housing programs during the Great Depression. Largely in response to the way he had used his veto power, in 1948, a new city charter was approved by the voters that weakened the mayor's power by implementing a city manager system and replacing the bicameral city council with a single nine-person body whose members were elected at large.

"The Warmth of Other Suns"

By 1927, the proportion of African Americans in the city dropped to less than 19 percent, due to annexation and the natural population movement. From 1915 to 1930, African-American residents sought better conditions and opportunities than in the rest of the South. The "Great Migration" affected Richmond, as well. World War I created demand for workers in northern cities, and the segregation of the late 1890s made living conditions

unbearable for many African Americans here. This was a decade of lost opportunities that could have been supported by the economic buoyancy of the twenties. According to a survey cited by Virginius Dabney of wage scales of African-American workers, the highest weekly pay rate was $18.54 (in the paper industry), and the lowest was $12.87 (in the tobacco industry). Workdays ranged from eight to ten hours a day and half days on Saturday. The pay for domestic workers was even lower, at $8.09 a week, but this included meals and uniforms. According to the Gilder Lehrman Institute of American History, the average yearly earnings in 1924 was $1,303.00. These Richmond rates would be $964.00 on the high end and $669.00 on the low end. There were no African-American principals in any African-American schools. This situation would not change until 1933. The Republican Party of Virginia made it plain that it was no longer the party of Lincoln and that it supported segregation.

For white Richmond, things went well. Private schools were flourishing, and in 1922, St. Gertrude's School opened. The Collegiate Schools received a large tract of land from J. Louis Reynolds for the Collegiate Country Day School. Windsor farms was designed in 1926, and by 1930, two former distinct English buildings had been erected in Windsor Farms—Agecroft Hall, home of T.C. Williams, and the Virginia House, home of Alexander and Virginia Weddell.

One unique piece of history took place in 1925, when the Chesapeake & Ohio Railroad tried to reopen a tunnel originally built in 1870 at Twenty-Fifth Street in Church Hill. The tunnel collapsed with a train inside. Two workers escaped, but two others were entombed with the locomotive. The tunnel remains sealed.

The 1920s was a time of intellectual change across the nation. H.L. Mencken, who wrote for the *Baltimore Evening Sun*, had few favorable things to say about the South. He covered the Scopes trial in Dayton, Tennessee. The issue of evolution and the teachings that used the Book of Genesis inflamed Richmond then as well as now. The Southern Baptist Convention adopted the statement by Dr. George W. McDaniel of the First Baptist Church that rejected any form of Darwinism. But the Reverend R.H. Pitt, editor of the *Baptist Religious Herald*, leaped into the fray. He said that no intelligent person believes the first chapters of Genesis to be literally true. How many took his side is unimportant. The result of his efforts prevented any anti-evolution legislation off the floor of the General Assembly. Those bills were introduced in every other southern state and passed into law in Tennessee, Arkansas and Georgia. Also during this time, Dr. Henry Hibbs founded the Richmond

Right: Agecroft Hall, Great Hall, Agecroft Foundation. Photo by Frances Benjamin Johnston (1864–1952). *Library of Congress*.

Below: Virginia House, 1929. Virginia Historical Society. Photo by Frances Benjamin Johnston. *Library of Congress*.

School of Social Work, which ultimately became Virginia Commonwealth University (see next chapter).

The decade ended the same way a wave crashes when it hits the shore. The stock market crash of 1929 ushered in ten years of economic privation for inhabitants of the city. The twenty-two-story Central National Bank building opened in 1929. It remained the tallest building in the city for many years. In 1930, Oliver Hill, who was born and practiced law in Richmond, and Thurgood Marshall began the study of law at Howard University and later helped argue *Brown v. Board of Education* before the Supreme Court in 1954. Change is a locomotive that pulls out of a station somewhere every day. The spread of automobiles would begin to change the city. It spelled the demise of the streetcar and made access to the suburbs more convenient.

THE GREAT DEPRESSION

Everyone has heard how the Great Depression forced many families into hardship. Some states and segments of the economy suffered more than others. Birmingham, Alabama, had one of the worst unemployment rates in the nation because of that city's reliance on steel. Across the nation, farm income fell the most for any economic segment. Richmond's unemployment rate was much less impacted by the Great Depression than those of other cities across the nation and in Virginia, but people still suffered, especially the African-American community. The reason for some degree of resilience, however, can primarily be attributed to the tobacco industry. Consumers continued to use tobacco products, and there was no substitute for it. The tobacco industry employed large numbers of people who performed many manual steps, from preparing the leaves to final packaging. Additionally, rayon remained in high demand because it could be used in the manufacture of stockings as a replacement for silk.

Richmond during the Depression was a tale of two cities. According to Ronald Heinemann's work on Virginia during the Depression, the impact varied. He does not always reveal the names of those he spoke with in private interviews in the 1970s. One lawyer had this to say: "It was bad here. Everybody was bewildered at the change. Money was scarce and almost everybody suffered a reduction in standard of living. Economically

everything slowed down about half. Nobody wanted anything done. There were business failures, much unemployment. My practice [real estate law] was especially affected."

But another Richmond attorney had a slightly different view: "Times were bad but not to the point of desperation even in the worst-hit communities. We tightened belts, hitched up trousers, economized, and resolved to beat the depression. In those days people did not want to be on relief. People found they could get along without many things including luxuries. They adjusted to the situation and life went along.…My family had to pull in our belts, eliminate vacation trips, [and] entertainment… alter and repair clothes, and reduce living costs to essentials."

Arthur Eure, a highway department employee, claimed the price decreases balanced out his salary cuts and enabled him to maintain his standard of living, but he recalled others "who did not fare so well. We who had jobs were told to…count our blessing and hold on for dear life." He remembered passing up two better-paying jobs just to hold on to "something certain,"

61d Richmond No. 4., c. 1930. Photo by Frances Benjamin Johnston. *Library of Congress.*

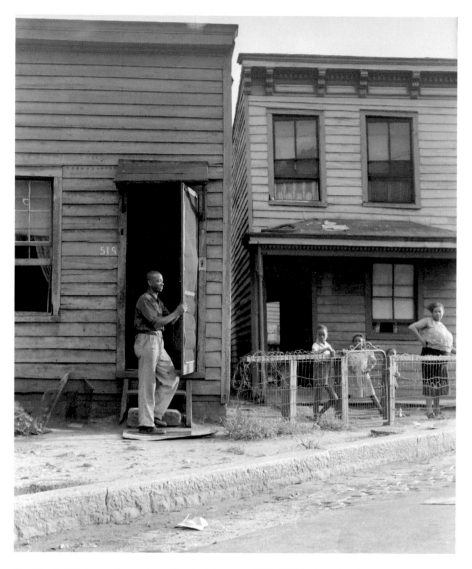

Families in Richmond stand outside their homes, 1938. WPA photo by Dorothea Lange, *$12 a month, no water no electricity. Library of Congress.*

demonstrating an obsession for security that affected many people for the rest of their lives.

People in Richmond believed their situation superior to those in many parts of the country, but they still felt afraid and apprehensive. In the 1930s, Friedman-Marks, a clothing manufacturer in Richmond, experienced a growth in sales from $1 million to $10 million annually,

per Dan Friedman in a note to Dr. Heinemann. That was an incredible amount of revenue for any company in those years. The passenger revenue of railroads declined, but the RF&P managed to hold its own by picking up additional freight customers. RF&P paid dividends between 1932 and 1939, which shows a great deal of confidence by its board of directors. Such bright spots, however, were few. In Richmond, housing for African-American families was deplorable. One-third of the houses had no water in the kitchen. In addition, 65 percent had no electricity, 70 percent had no inside bath facilities and 75 percent had no gas. Richmond resident Leroy Whaley related to Heinemann, "Depression in Richmond was very bad. Many people not only went without food but also clothes.... You couldn't afford a good house." Blatant discrimination against African Americans in Richmond also occurred when they were outright denied relief. Ultimately, African Americans made up over half of Richmond's relief rolls. The *Richmond Planet* encouraged "buy black campaigns" and hoped to shock the liberal white conscience of the city.

Before the Great Depression, the city's primary relief-dispensing agency was the Family Service Society, which received its funds from the Community Chest organization, which evolved into today's United Way of Richmond. Support to those in need was also provided by Catholic Charities, the Red Cross and the Richmond Social Service Bureau, funded mostly by the city. But the need quickly overwhelmed these resources, and the tight-fisted General Assembly would not appropriate any additional funds. Fortunately, in 1933, with the election of Franklin Roosevelt the previous year, things began to improve. At least Richmond's financial foundations were solid, so there was something to build on. Only the American Bank and Trust Company of Richmond closed its doors after the Bank Holiday in March 1933.

The advent of the New Deal had a tremendous impact not only in Richmond but also across the nation. After the stock market crash of 1929, conditions generally deteriorated in Richmond along with the rest of the nation. As already mentioned, tobacco manufacturing did not decline as much as many other industries, and rayon made by DuPont here provided an alternative to silk. But many businesses had to cut back. The creation with federal funds of the Virginia Emergency Relief Administration created work, with improvements focused on schools, sanitary facilities, airport projects, park improvements and street repairs. But the biggest boost to Richmond's economy came from the Public Works Administration (PWA), a construction-focused federal agency. Some of the projects funded

by the PWA in Richmond include the Lee Bridge, the former Virginia State Library building (now the Patrick Henry Building), Maggie L. Walker High School and the Medical College of Virginia Hospital.

Virginia Museum of Fine Arts

Another project that the PWA was willing to support was the completion of the Virginia Museum of Fine Arts (VMFA) in 1936. As improbable as it sounds, one of the nation's great museums took shape during one of Richmond's and the state's darkest economic periods. The museum occupies the site of the former Confederate Soldiers' Home, which housed poor and infirm Confederate veterans and closed permanently in 1941. The R.E. Lee Camp No. 1, as it was called, stood in the open space directly behind the present museum structure. Perhaps it was Richmond's sense of overcoming adversity that provided a portion of the desire to go ahead with such a bold project.

The inception of VMFA dates from 1919, when John Barton Payne donated his art collection to the Commonwealth of Virginia. He also donated $100,000 in 1932 toward the construction of a museum, provided the funds could be matched. Governor John Garland Pollard got the PWA to provide construction funds and the state to provide maintenance funds. In the ensuing years, many bequests and donations flowed into the museum, requiring additional space, completed in 1954. The continuing influx of art required still more space, and in 1970, the South Wing opened. The Commonwealth of Virginia funded the addition. The pace of acquisitions from donors such as Ailsa Mellon Bruce, Sydney and Frances Lewis and others required another wing. The North Wing was completed in 1976. Major additional gifts from the Mellon and Lewis families necessitated more space. The West Wing opened in 1985. The most recent expansion—the James W. and Frances G. McGlothlin Wing—opened on May 1, 2010. It added 165,000 square feet to the existing 485,000 square feet. Many prominent Richmond and Virginia families, along with individual donors, make the VMFA the top-ranked place to visit in Richmond. Tyler Green, in his *Modern Art Notes* podcast in 2010, said, "After a four-and-a-half-year, $150 million expansion, Richmond's Virginia Museum of Fine Arts has turned itself into North America's 14th-largest museum, an impressive feat considering that Richmond is the United States' 43rd-largest metropolitan

area." The museum is among the top twenty museums in the nation. It is free and open 365 days a year. It alone makes Richmond a wealthy city for its inhabitants and visitors.

SURVIVING THE GREAT DEPRESSION IN RICHMOND

Besides the initial funding of the VMFA by federal funding, many other programs that provided support came to Richmond from the PWA. Starting in 1933, direct relief became available to ordinary citizens. The Federal Emergency Relief Administration (FERA) started as a distributor of direct relief to the states, but Virginia, among many other states, did not possess a willingness to support direct relief. Instead, Roosevelt created the Civil Works Administration (CWA), a short-lived job creation program, to employ four million Americans in a variety of small work projects at the local level. Heinemann in his book reports that H.H. McCanna, the head of the Richmond District of the CWA, said, "Time and again CWA employees stated that their jobs and been 'lifesavers' to them, and there was no doubt that the statement was the truth." The government aided citizens through FERA with a combination of direct relief and special programs. At the bottom of the Depression in 1934–35, the average number of people receiving relief in Richmond was 17,598. The Citizens' Service Exchange, established by the Richmond Council of Social Agencies in 1933, provided relief other than food—fuel, clothing, shoes, furniture—on a work-exchange basis for the destitute. Hundreds of poor Richmonders participated in the cooperative. The exchange established scrip as a medium of payment to workers, who could exchange it for products in the exchange's stores. Additionally, the unemployed could go to the strip deposits near Robious, in Chesterfield County, and haul away free coal. There was distrust of providing money directly to those in need. The exchange also trained people for useful jobs. It remained in operation until 1945, when it became the Richmond branch of Goodwill Industries.

Also, there were many transients in Richmond. There were more than eleven thousand transients registered in 1933. They were housed in the YMCA, the Salvation Army and private homes in some instances. They earned scrip for cutting wood, serving as janitors and filling other odd jobs. The rate was the equivalent of three cents an hour! These arrangements curtailed begging and panhandling.

The Impact of Individuals

The 1920s and 1930s provided evidence of the efficacy of influence when individuals of average means and position step forward. Anti-evolution laws made their way into legislative sessions in every southern state except Virginia. Reverend Dr. R.H. Pitt, the editor of the *Baptist Religious Herald*, stated, "There isn't an intelligent Baptist 21 years old…who would be willing, if he stopped to think about it, to give his approval of the declaration… that the first chapter of Genesis is literally true." He also helped defeat a bill that would have made Bible reading compulsory in public schools. John Barton Payne donated his collection of paintings as the foundation of the collection of art that would become the VMFA. Mary Munford, in addition to her work for public education, led the effort to admit women to the University of Virginia. She almost succeeded in 1916, losing by only two votes in the General Assembly, but she fired the first shot over the bow. Lila Valentine focused on the horrifying condition (including rats and filth) of Richmond's only high school at that time, resulting in the construction of the "old" John Marshall High School. There are many other citizens, especially during the civil rights era, whose courage and foresight deserves recognition. These are just a few.

However, there are also those who set up roadblocks and would not lift a finger to lift up another human being. J. Fulmer Bright deserves special reproof. Bright served as mayor of Richmond from 1924 to 1940. As mayor, he believed in limited government and frequently vetoed development projects. His middle name should have been "No." He also restricted the employment of African Americans in city jobs. Largely in response to the way he had used his veto power, in 1948, a new city charter weakened the mayor's power by implementing a city manager system that replaced the bicameral city council with a single nine-person body whose members were elected at large.

End of the Decade and World War II

In 1938, the Reynolds Metals Company decided to move from New York to Richmond. The Deepwater Terminal project was completed in 1940 on a 333-acre tract a few miles below the city. Richmond overall weathered the Depression better than most cities. By 1937, Virginia had

exceeded all the industrial indexes of 1929—salaries, wages, number of workers and sales—due to tobacco and an environment that prompted industries to relocate here. "Richmond's increase of 44 percent made it the fastest growing industrial center in the nation," according to R. Heinemann. Richmond also grew physically. In early 1942, shortly after Pearl Harbor, Richmond annexed seventeen square miles of Henrico and Chesterfield Counties, containing approximately twenty thousand residents. This dropped the proportion of African Americans in the city to just above one-quarter. Richmond significantly grew as a transportation hub with the creation the Defense General Supply Center, Bellwood. Friedman-Marks Clothing produced things such as peacoats for the U.S. Navy. Tobacco production and shipments overseas soared. DuPont fibers produced materials for parachutes, munitions and gunpowder bags. At the peak of wartime production, Reynolds Metals and DuPont were the city's largest employers. The year 1946 marked a turning point for Richmond's economy. In that year, the highest level of business activity was recorded in the history of the city. Within one year, Richmond was the fastest-growing industrial center in the United States.

8

RICHMOND 1945–1975

*Men make history and not the other way around. In periods where there is no
leadership, society stands still. Progress occurs when courageous, skillful leaders
seize the opportunity to change things for the better.*
—*Harry S Truman*

When World War II ended, Richmond could celebrate not only
the Allied victories and soldiers returning home but also its
many industries and businesses operating at high output and
great efficiency. In 1948, the city's charter established the city council as
the primary governing body. A referendum returned the city to the council-
manager form of government. The referendum passed by a vote of 21,567
to 8,060, the largest turnout in history up to that time. The position of
mayor, except for some legislative duties, became mainly ceremonial; most
of the administrative and appointment responsibilities were transferred
to the city manager. This format lasted a little longer than fifty years. On
January 1, 2005, the City of Richmond began operation under the mayor-
at-large form of government. The mayor is no longer chosen from among
the city's nine elected council members but at large by the citizens of the
city. The first elected mayor under this new structure was the Honorable L.
Douglas Wilder, who served from 2005 to 2009. He had previously served as
governor of Virginia (1990–94).

The city annexed parts of both Henrico and Chesterfield Counties in
1942. In 1940, the population of the city reached 193,042 and grew to

230,310 in 1950. Henrico County grew from 41,960 in 1940 to 57,340 in 1950. For the same period, Chesterfield County grew from 31,183 to 40,400. Today, both counties have populations that exceed Richmond's.

As veterans returned home, the city began to shift its focus from tasks that preoccupied it during the war to a period of normalization. The Richmond Public Library system was open to all starting in 1947. On July 26, 1948, President Truman, realizing that southern senators would filibuster desegregation legislation, issued Executive Order 9981, which stated, "there shall be equality of treatment and opportunity for all persons in the armed forces without regard to race, color, religion, or national origin." The effect of the armed forces being more openly integrated during the war raised the expectation of greater equality in civilian life. During this period, segregation barriers at hotels, buses, restaurants and theaters slowly went away. This twenty-five-year period mirrored the nation's greatest improvement in rights for African Americans, as well as some unique advances in Virginia and the city, too. Specific events led to these changes.

After leaving the army at the end of World War II, Oliver Hill, who graduated second in his class (1933) at Howard University behind Thurgood Marshall, settled again in Richmond, his birthplace. Following the change in the city charter, Hill ran for city council for the second time in 1949 and became the first African American on the city council of Richmond since Reconstruction. Because of his legal work and calls for equality in the 1940s and '50s, the safety of Hill and his family were often threatened. On April 23, 1951, sixteen-year-old Barbara Johns led 450 students to walk out of R.R. Moton High School in Farmville, Virginia, to protest the poor condition of the housing of African-American students. That year, a team including Hill, Samuel Tucker and Spottswood Robinson took up their cause and sued the Prince Edward County Board of Education. This action was one of five cases combined into *Brown v. Board of Education*, which challenged as unconstitutional state laws establishing separate public schools for African-American and white students. The U.S. Supreme Court ruling that "separate but equal" educational facilities were "inherently unequal" was the defining factor in Richmond politics from 1953 to 1977 and overturned the power structure that had been in place for approximately one hundred years.

Because the most notorious events and horrific images of the civil rights movement of the sixties were from the Deep South, Virginia's role in the movement tends to be underplayed. In 2008, the Virginia Civil Rights Memorial, featuring figures and quotes from the national civil rights movement, was installed on the grounds of Capitol Square. In another

incident, on the early morning of July 11, 1958, Richard and Mildred Loving were arrested in Caroline County, just north of Richmond, in violation of a Virginia law banning miscegenation. The first round of appeals, which the Lovings lost, played out in Richmond and was heard by the Virginia Supreme Court before being overturned by the U.S. Supreme Court in 1967. This ruling struck down the last group of segregation laws on the books in all southern states—those requiring separation of the races in marriage. It was widely accepted in Caroline County, at least, that many children came from mixed races; race relations were generally good. If no one challenged the laws, all was calm.

The edifice of segregation going back to the time of Jim Crow laws at the end of the nineteenth century slowly began to crumble in Richmond and across the South. In Richmond, an action called "selective buying" put pressure on stores, especially against Richmond's two major department stores—Miller & Rhoads and Thalhimers—to serve African Americans on the same terms as whites. A group of students from Virginia Union University, known as the "Richmond 34" or "Union 34," challenged the lunch counter policy of Thalhimers Department Store on February 22, 1960. The U.S. Supreme Court decision in 1954 ending segregated

Monument on Capitol Square honoring Virginians who were active in the civil rights movement. *Photo by Kimberly Hise Photography.*

schools sent a wider message about racial equality to Richmond and all municipalities that change was on the way. There were many small local protests in Richmond, especially in front of city hall, that were highly visible. Historically, each protest, no matter how small, leads ineluctably to another one. That's just how change works.

Richmond remained generally calm on the surface even as change percolated during this time. As an example, credit for smooth change inside public education goes to Lewis F. Powell Jr., chairman of the Richmond School Board who later was appointed to the U.S. Supreme Court, and Booker T. Bradshaw, an African American who was vice-chair of the school board. Meanwhile, the Crusade for Voters, founded in Richmond in 1956, registered many new African-American voters. Previously, the Crusade for Voters was the biracial Richmond Citizens Association, but it was perceived that this organization did not adequately represent labor and African Americans sufficiently. Richmond Forward, a civil rights organization led by Thomas C. Boushall, was formed in 1963.

Unfortunately, at the same time, segregation in Richmond moved from explicit signs and laws separating the races to an implicit form of segregation—whites moving out of the city to the surrounding counties. An additional factor was that it was becoming cheaper to live outside the city because of taxes. In 1950, there were 33,106 pupils in Richmond Public Schools, with a breakdown of 19,797 whites and 13,909 African Americans. By 1970, the total number of pupils stood at 48,013—17,364 whites and 30,649 (64 percent) African Americans. At the end of this period (1975), 78 percent of the students were African American. A final attempt by U.S. District Court judge Robert R. Merhige Jr. to consolidate Richmond with Chesterfield and Henrico Schools was blocked by the U.S. Supreme Court. But Richmond advanced in many cultural aspects.

Major Richmond Institutions

Richmond began this period with all political and cultural activity highly concentrated inside the city limits. But as urban sprawl began during this time, the appearance of the city, its governance, economy and transportation systems changed radically. Richmond during this time was still a city of white tablecloths and workers punching time clocks. Many women went to the Miller & Rhoads Tea Room for lunch, where Eddie Weaver played the

organ. Mothers and families took their children downtown to either Miller & Rhoads or Thalhimers to meet Santa Claus and tell him what they wanted for Christmas. Weaver also played the Wurlitzer organ between evening performances at Loew's Movie Theatre (600 East Grace Street), which has since become the Dominion Arts Center. The Byrd Theater (2908 West Cary Street) also has a grand Wurlitzer organ that can still be heard between movie showings. For the white middle class, Richmond had it all. What today is the Diamond along the Boulevard was previously known as Parker Field. It was converted for use as a baseball field in 1954. The city's minor league baseball team, the Richmond Virginians, played in the International League. The team lasted for ten years. After two years with no team, the Richmond Braves baseball team formed. The city and surrounding counties jointly replaced Parker Field with the current Diamond in 1984.

The construction of the Richmond Coliseum in 1971 became a great addition to the city's infrastructure, vastly expanding entertainment and sport options. Many rock, country and soul musical acts, as well as other kinds of entertainment, had venues of varying sizes to choose from, giving citizens many new options.

Richmond Symphony

As incomes grew, cultural expectations and pride expanded. A forerunner to the Richmond Symphony failed during the Great Depression, but another attempt in 1957 succeeded. On April 15, 1957, a meeting was held by several Richmond citizens to organize what is today the Richmond Symphony. The first meeting consisted of Mrs. William R. (Emma Gray) Trigg Jr., Mrs. David E. Satterfield Jr., Miss Helen DeWitt Adams, Dr. John R. White, Mr. Frank G. Wendt (later a member of the orchestra) and Mr. Edmund A. Rennolds Jr. They, in turn, recruited Brigadier General Vincent Meyer as president. He initially declined but then agreed to serve to raise the funds necessary to launch. Here is another example of likeminded citizens forming an initial nucleus and then adding a community leader to push the effort forward. Richmond has a long tradition of private initiatives that enhance the public good. Edgar Schenkman, who had conducted the Norfolk Symphony Orchestra for ten years, agreed to serve as conductor and led the orchestra from 1957 to 1971. Now, in 2017, the symphony celebrates its diamond anniversary.

Several African-American men born in Richmond had distinguished musical careers. Paul Douglas Freeman (1936–2015) graduated from Rochester School of Music and became a conductor. He founded the Chicago Sinfonietta, of which he remained the musical director until his retirement in 2011. Isaiah Jackson III was born in 1945 in a predominantly black neighborhood of Richmond, the son of an orthopedic surgeon (also named Isaiah Allen Jackson) and his wife, Alma Alverta Jackson (née Norris). Arthur Ashe was one of his childhood friends. Jackson was the first African American to be appointed to a music directorship in the Boston area. Most of his education after the age of fourteen took place outside of Richmond. Additionally, Dr. Leon E. Thompson, who attended Armstrong High School, later graduated from the University of Southern California and worked in New York for his entire career. The Abyssinian Baptist Church men's chorus was named in his honor.

Richmond was also a city of writers. During this period, Douglas Southall Freeman retired as editor of the *Richmond News Leader* to concentrate on finishing his biography of George Washington. He had previously written *R.E. Lee: A Biography*, for which he won a Pulitzer Prize for biography. He subsequently wrote *Lee's Lieutenants: A Study in Command* (1942–44). He won his second Pulitzer Prize, posthumously, for his seven-volume biography of George Washington. He is one of only forty-five persons to win two or more Pulitzer Prizes in the category of Arts & Letters. There were many other excellent writers living in Richmond at the time or hailing from Richmond, but Freeman stood out, perhaps because he was also the editor of the *News Leader*.

Virginia Commonwealth University

Although the origins of Virginia Commonwealth University (VCU) date from 1917, it really began to grow and achieve prominence between 1950 and 1975. In 1917, what became VCU started out as the Richmond School of Social Work and Public Health. Virginius Dabney wrote, "Its founder was Dr. Henry H. Hibbs, an able young man who affords one of the foremost examples in Richmond's history of how to make bricks without straw." Dr. Hibbs approached a powerful banker, John M. Miller, president of First National Bank, to solicit support and

funds for "training nurses to take doctors' places" in World War I. It was called the Richmond School of Social Work and Public Health. In 1925, it became part of the College of William and Mary and took the name Richmond Professional Institute (RPI) in 1939. There was no state or local funding, but a financial campaign led by T.M. Carrington raised $100,000, enough to launch the school. The first building was the Saunders-Willard house at Shafer and Franklin. Only three years later, the School of the Arts opened under the leadership of Theresa Pollak, who retired in 1970, by which time the school was one of the best known in the nation. The other element that established RPI was the purchase of late nineteenth-century and early twentieth-century houses on Franklin and Grace Streets. During the 1930s, major repairs were made from grants from the WPA. VCU was built from mansions, stables and lofts in those early years.

That's how affairs stood until, in 1968, the General Assembly combined the Medical College of Virginia and RPI into Virginia Commonwealth University. Since then, the school's growth has been nothing but explosive, with many new buildings and programs. The Medical College of Virginia (MCV) began operations in 1838 as the Medical Department of Hampden-Sydney College, which explains why 1838 is listed as the founding of VCU. MCV started out holding classes at the old Union Hotel. MCV's first building was known as the Egyptian Building and can still be seen at 1223 East Marshall Street. Most activities of MCV were conducted there until the 1890s. By 1854, MCV was no longer a part of Hampden-Sydney College. The current VCU School of Medicine dominates the area bounded by East Broad Street and the I-95 corridor. It is highly regarded for both the care it provides and the quality of its graduates.

The baby boom generation, those born between 1946 and 1964, reached college age beginning in 1963 and drove up attendance at RPI around Monroe Park, which influenced the evolution to VCU and is the reason that former RPI campus is now known as the Monroe Park Campus. The growth in the percentage of high school graduates going on to college also drove the growth of Virginia Union University and the University of Richmond, two other large centers of higher learning. Additionally, VCU has achieved renown for its outstanding athletic programs.

UNIVERSITY OF RICHMOND

The university histories laid out here touch on institutions that were created to meet a need. Today, corporations create for-profit colleges not only to meet an underserved need but also to seize an opportunity. The University of Richmond began in 1832 as a Baptist training seminary. It moved to a mansion called Columbia along Lombardy Avenue between Broad and Grace Streets. Richmond College was incorporated in 1840 by the General Assembly. The school closed during the Civil War. Its endowment, invested in Confederate bonds, became worthless. The college reopened in 1866, and the law school was established in 1870. After 1894, when Frederic W. Boatwright became president, the college began its ascent to significance. President Boatwright served for fifty-one years. Most major institutions can trace their preeminence to the long tenures of leaders of vision, which provides a continuity that is hard to duplicate. During his tenure, the college raised the funds to move to its present location in 1914. Many of the major Gothic and brick buildings date from that time. It became the University of Richmond in 1920.

In 1946, George Modlin, from Princeton, became president. He was admired both as an amiable administrator and an excellent fundraiser. In 1969, when financial issues threatened closing the university or turning it over to the Commonwealth of Virginia, E. Claiborne Robins Sr., trustee and alumnus, donated $50 million to the university, the largest gift made to an institution of higher education at the time. The university went to the next level with that funding. Another donation of $20 million in 1987 by Robert S. Jepson Jr. facilitated the opening of the Jepson School of Leadership Studies, the first of its kind. Since then, Carole and Marcus Weinstein, among many others, have provided exceptional funding. The University of Richmond, too, has outstanding athletic teams and facilities that enhance both the school and the city.

RICHMOND BALLET

A group of ballet enthusiasts formed a loose association in 1957. They rehearsed and performed for almost twenty years when, in 1975, the School of Richmond Ballet formed. Funding from Mr. and Mrs. William Massey Sr. provided the Richmond Ballet its first official residence in 1978 at a

former hardware store on the corner of Lombardy and Broad, across the street from the former Richmond College location. It is the first professional ballet company in Virginia and was designated the State Ballet of Virginia in 1990 by Governor Wilder. In 2000, Richmond Ballet moved into a newly renovated, state-of-the-art facility at 407 East Canal Street in the heart of downtown Richmond. The spectacular building boasts 53,500 square feet and is a generous donation from the Reynolds Metals Company. Once again, a core of devoted citizens with help from corporations and philanthropists created a public benefit.

Many organizations and artistic endeavors sprang up after the war. On April 29, 1947, the Richmond Choral Society, to name just one, formed and continues to this day. Many other amateur musical groups and theater organizations formed since the end of World War II. Richmond's arts reflect the wide variety of the human experience.

THE STREET WHERE THE TERRELLS LIVED IN 1958

Average middle-class families prospered in the city during this period. As an example, my family lived at 3314 Cliff Avenue, a narrow one-way street on the north side of the city. The houses, mostly built in the 1930s, are close together; the neighbors could not help but know one another well. The Terrells' next-door neighbors, the Gatewoods, bought a new car every other year. It was a big event when everyone on the block came after dinner to view the engine when Mr. Gatewood proudly lifted the hood of his 1958 black and gold Ford Fairlane. During this time, Mercury and Edsel made cars with rear windows that could be lowered, to prevent rain from getting in. In 1955, record eight million automobiles were sold in the United States. My father was an auto mechanic, and my mother was a hairdresser.

Income disparity was less pronounced then. Across the street lived a young doctor with his wife and three children. A couple without children lived across the alley. They could be found working in their garden every day, since Donan Williams was a machinist at American Tobacco company who worked the late shift. His wife, Maybelle, worked second shift there. They gave away flowers to neighbors when their irises, roses and chrysanthemums bloomed. Mr. Williams had a mangled left arm from a work accident. We don't see as much evidence of industrial accidents in the city today, since manufacturing is safer and many more office jobs exist

than in times past. It was truly a Norman Rockwell kind of world then for a portion of population.

Changes in the working status of women after the Depression and World War II had firmly taken hold in Richmond and across the nation. Many mothers on our block held office jobs. Mrs. Terrell hired a woman to do what was euphemistically called "day's work." Sally Miller cleaned, washed and ironed, plus did some cooking. She was raising two children of her own and lived in Gilpin Court—subsidized housing built by the Richmond Redevelopment and Housing Authority. She took public transportation to her work (she worked for several different families). She was cheerfully poor. Mrs. Terrell paid Social Security as part of Mrs. Miller's pay (and encouraged other friends to do so, as well); this would allow Mrs. Miller to claim Social Security in her old age. After both Mrs. Miller and Mrs. Terrell became elderly, I drove her to St. Paul's Street to visit Mrs. Miller on holidays to deliver gifts. Everyone knew the roles they were supposed to play. Gilpin Court was safe for everyone until the later part of the twentieth century.

WHITE FLIGHT AND CHANGE COME TO JACKSON WARD

Fear of African Americans caused white families to head for the neighboring counties. The ostensible reason was that property values would decline. The first family to sell to African Americans was given the sobriquet of "block breakers." More-expensive neighborhoods remained white, simply because the cost of the homes was too high for most black families. Public schools gradually became predominantly African American and remain that way today. According to the Private School Review, Richmond has twenty-five private high schools and fifty-six elementary schools, most affiliated with a religious organization.

The opportunity for African-American families to improve their housing led to a decline in their former neighborhoods. Also, the construction of the Richmond–Petersburg Turnpike (now I-95 through downtown) in the 1950s led to the destruction of many blocks of homes and businesses in Jackson Ward, splitting the old ward apart. In 1976, Jackson Ward received a place in the National Historic Register, but it was too late to save much of what had been there.

In 1896, the U.S. Supreme Court upheld *Plessy v. Ferguson*, permitting jurisdictions to establish separate but equal educational facilities. On May 17, 1954, however, in *Brown v. Board of Education*, the court, in a unanimous decision, declared state laws establishing separate public schools for black and white students to be unconstitutional. The impact on Richmond made the city what it is today. The Supreme Court issued a second part of its decision on May 31, 1955, saying that integration of schools must proceed with "all deliberate speed." Oliver Hill's team of lawyers filed more civil rights cases in Virginia than were filed in the segregation era in all other southern states combined; as many as seventy-five cases were pending at a time. Giants started to walk among us.

In 1956, Hill spoke at a hearing before the Virginia General Assembly against a bill that would restrict the National Association for the Advancement of Colored People in its fight against segregation. He accused the lawmakers of trying "to build a Wall of China around Virginia while segregation is breaking down outside the state." According to the *Richmond Afro-American*, he continued his remarks: "This wall will crumble too. You can pass all the legislation you want. You obviously have the power to pass it, but power does not make right." These remarks would not have even surfaced fifty years earlier, before Jim Crow laws were challenged. The rules of the game started to be rewritten.

On school integration issues, Richmond, and Virginia, began to use the tactic known as "Massive Resistance," a group of laws, passed in 1956, intended to prevent integration of the schools. It was as if the Civil War had settled nothing and governments could select which national laws they would obey. What broke the back of this movement was a delegation of business leaders meeting with Governor Lindsay Almond. They told him that national corporations would not come to Richmond in such an environment, that resistance was a threat to continued industrial and commercial development. Elected officials no longer pledged support to Massive Resistance. Additionally, courts began to overturn segregation laws.

According to Benjamin Campbell, Richmond as it is today was shaped by three decisions that occurred within months of one another in 1971. Curtis Holt, a resident of Creighton Court, a public housing project in Church Hill, sought to block the annexation of a portion of Chesterfield County. The U.S. Department of Justice joined the suit. Richmond was enjoined from holding any elections until the matter was resolved. The period from 1970 to 1977 was the longest in history that any city had been blocked by federal courts from holding elections. The three events were as follows:

1. The February 24, 1971 challenge to the annexation of twenty-three square miles of Chesterfield County brought by Mr. Holt and the Department of Justice.
2. The March 1971 law by the General Assembly that prohibited Richmond from annexing any additional land from surrounding counties.
3. An April 1971 order by Judge Robert Merhige ordering Richmond Public Schools to bus students throughout the system to achieve equal integration across the schools.

From here on, white families with schoolchildren began to move to the counties, reflecting the rejection by citizens of integrated schools and of higher city taxes. The only winner under these circumstances was the African-American electorate; for the first time, it held the majority of city council seats. The city had its first African-American mayor, Henry L. Marsh.

FULTON

A sad chapter in the rush to improve Richmond with federal monies through the execution of redevelopment projects was the destruction of the Fulton area. By the 1960s, the area at the base of the hill bordering Gilies Creek was home to mostly low- and middle-income African Americans. The housing stock was regarded as rather shabby, and after very severe flood damage in the early 1970s, many residents accepted money from the Uniform Relocation Assistance and Real Property Acquisition Act (1970) and relocated elsewhere in the city. Eventually, the entire Fulton Bottom community was demolished, marking Richmond's only neighborhood-wide urban renewal slum clearance. It was vacant land for decades but is now being redeveloped properly. One Fulton resident who went on to achieve prominence was Samuel L. Gravely Jr., the son of Mary George Gravely and postal worker Samuel L. Gravely Sr. He became the first African-American admiral in the U.S. Navy in 1971, just before Fulton was razed. He graduated from VUU in 1948.

Despite transition and turmoil, Richmond prospered. As the state grew, there were more state workers in more buildings. Richmond achieved its highest population in 1970, when the city had 249,621 residents after its final annexation. The Sixth Street Market opened downtown, as did many other

Virginia War Memorial's Shrine of Memory, twenty-three-foot marble statue, designed by Leo Friedlander and sculpted by Joseph Campo and William Kapp. *Photo by Misti Nolen.*

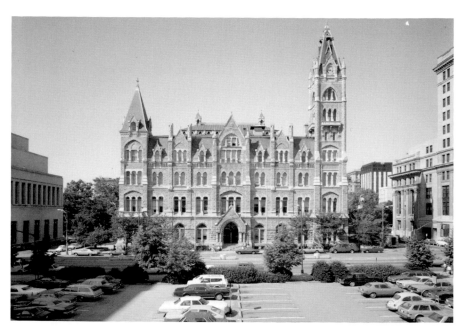

Old City Hall (north façade), 1001 East Broad Street. (No date.) *Library of Congress.*

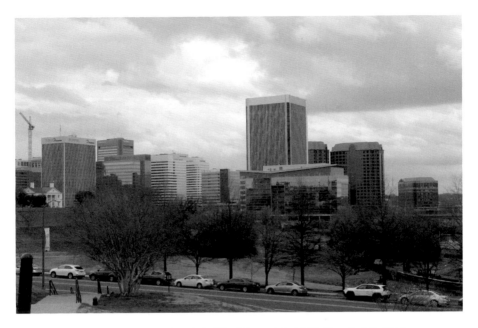

Downtown and river view from Virginia War Memorial, 2017. *Photo by Misti Nolen.*

revitalization efforts. The destruction of historic structures created a new awareness of the city's history. Richmond has always looked forward and backward simultaneously. Circuit City, headquartered in Richmond until its bankruptcy in 2009, was founded in 1949 by Samuel Wurtzel as the Wards Company and pioneered the electronics superstore format in the 1970s. It was a phenomenal American success story. The Virginia War Memorial (621 South Belvidere Street) opened in 1956 and offers a grand view of the city and the river. In 1957, in another effort to honor those Richmonders who died in World War II, Richmond Memorial Hospital opened on property donated by D. Tennant Bryan along with the family mansion, Laburnum. In 2008, it was converted to condominiums called Ginter Place. In 1973, a structure in Shockhoe Bottom that would become the Tobacco Company Restaurant was renovated, spearheading the redevelopment of that area. In 1957, Sydney Lewis, along with his wife and his mother, founded Best Products, which flourished with the introduction of "catalogue-showroom merchandising." After they sold the business, they donated large sums to local institutions, including the Weinstein Jewish Community Center, VUU and VMFA (giving art and money to the latter). By 1975, Richmond had much to be proud of.

9

RICHMOND AFTER 1975

You must not lose faith in humanity. Humanity is an ocean; if a few drops of the ocean are dirty, the ocean does not become dirty.
—*Mahatma Gandhi*

Richmond in 1975 was a city wavering between its past and its future. Its population went down from 249,621 in 1970 to 204,214 in 2010 but has begun to grow again. Many other American cities were experiencing urban decay, the flight of wealth to the suburbs, disparities in public schools and general unrest, but Richmond's unique history meant that these issues were particularly acute and often quite difficult to manage in ways that would mollify white voters who, at heart, did not want integrated schools. During these years, the city's population went from majority white to majority African American. Emotions were strong and very often boiled over into open conflict. Despite the challenges, Richmond moved forward and, in some cases, provided innovation for other cities to copy.

Richmond was one of the test cases for desegregation, part of massive resistance, busing, protests and contentious disagreements in both the General Assembly and other political venues. In 1970, Governor Linwood Holton made headlines by enrolling his white children in an almost exclusively black school in the city. Under his administration, busing for racial balance began, and it continued through the 1970s and into the '80s. In 1974, the U.S. Supreme Court differentiated between segregation caused by policy and segregation that arises any other way, such as boundaries drawn without

intent to create segregation. Busing was no longer required. According to Old Dominion University, integration peaked in roughly 1984 and has been declining steadily since then in Richmond and other cities. According to *Style Weekly*, the schools in Richmond are presently more segregated than they were in 1970. Nevertheless, city leadership has consistently worked toward recognition of the past and hope for the future, as this 2007 ordinance creating Oliver W. Hill Day demonstrated:

> *To designate May 1 of every year as "Oliver W. Hill Day" as a day to celebrate the contributions to our society made by Mr. Hill; to encourage all citizens to reflect on Mr. Hill's contributions to end racial segregation and racial discrimination and to contemplate what actions they can take to bring about greater equality in our communities; and to commend the dedication to equality and the contributions to public service made by Mr. Hill during the course of his professional career as a shining example of civic duty to be emulated by all citizens of the City of Richmond. (Proceedings of Richmond City Council, council president Pantele presiding, May 24, 2007)*

Virginius Dabney, in his history of Richmond, highlights many positive changes happening during this same period (the 1970s): rapid expansion of enrollment and facilities at Virginia Commonwealth University (VCU) and the Medical College of Virginia (MCV); completion of the Richmond Coliseum; construction of the city freeway (part of which is now Interstate 95); the rise of modern apartment buildings; the presence of the Thalhimers and Miller & Rhoads department stores; completion of the expansion of a modern public library system; and a new wing in the Virginia Museum of Fine Arts (VMFA), to name just a few. Still, the seventies also presented significant challenges to city residents and leaders: economic shifts (an attempt to revitalize downtown with the Sixth Street Market would fail); lack of collaboration with the neighboring counties (primarily Chesterfield and Henrico); and chronic issues related to poverty and unequal opportunity.

It was also in the mid-1970s that renewed interest in restoring the Richmond waterfront downtown gained new life. In 1971, the James River and Kanawha Canal Historic District entered the National Register of Historic Sites, and planners envisioned restoring areas of the old canals, basins and businesses from the antebellum and earlier periods. The Canal Walk was completed in 1999, offering boat rides on the restored portions of the Kanawha and Haxall Canals, along with biking, walking and access to businesses in the area.

By the mid-1980s, Richmond was starting to see many positive changes. VCU began a long period of phenomenal growth and expansion that culminated in it becoming the largest university in the region in the early twenty-first century, with greatly expanded enrollment and diversity of programming.

In 1984, a new baseball stadium called the Diamond opened, and the AAA Richmond Braves began to play for hometown fans. This actually represented only one event in a long tradition of professional and semiprofessional baseball in Richmond, as the author has previously written:

> *The variety of stadiums and locations where the game was played over time is impressive. In 1884 the Virginians' stadium was on the site of the present-day Robert E. Lee monument; there were early ball fields at the old fairgrounds at Monroe Park; the Colts played games at Tate Field on Mayo Island in 1940, and in 1942 moved to Mooers Field at Roseneath and Norfolk streets in Scott's Addition; Parker Field (built in 1934) replaced Mooers in 1954 and was at the fairgrounds; the Diamond was first used in 1985. Perhaps, Richmond will have another stadium soon, as the history of yesterday indicates there will be.*

L. Douglas Wilder was sworn in as the first African American elected governor of a state in 1990. Wilder, a participant in the civil rights movement, educator, elected leader and progressive thinker, brought further healing to Richmond and the country by his service as governor and later as mayor of Richmond. Wilder is now commemorated in the naming of VCU's L. Douglas Wilder School of Government and Public Affairs, an independent school within the university that promotes social science and social justice, and he works very closely with the city government and citizens to make Richmond a more equitable place to live and work.

In 1995, the floodwall was completed. The *Richmond Times-Dispatch* summarized the event:

> *The floodwall was dedicated on October 21, 1994, at a cost of $143 million. The floodwall system extends more than 3 miles on both sides of the James River. It was designed to keep floodwaters from the river out of Shockoe Bottom and Manchester. It was designed to protect Richmond from floods of up to 32.0 feet, which would have stopped all the recorded floods except Tropical Storm Agnes, which hit 36.5 feet on June 23, 1972. The second worst was Hurricane Juan, whose flood reached 30.8 feet on*

November 7, 1985. Tropical Storm Camille's flood was the third worst, at 28.6 feet on August 22, 1969.

In 1995, a statue of Arthur Ashe was added to Monument Avenue, which to that point had consisted mainly of monuments to figures from the Civil War. Memorializing Ashe, a local son and globally respected tennis star, represented yet another chance for Richmond to reconcile its past and future.

In 1998, Tim Kaine was elected mayor by the city council and took on a more activist role in addressing Richmond's needs. Working in conjunction with the city manager, Kaine tackled such issues as: renovation and repurposing of older structures; remodeling and construction of new public schools; initiatives that effectively reduced violent crime; and reduction or opposition to a number of taxes, which, as a result, was credited with spurring significant economic growth for the city. In addition, the mayor's sensitivity to issues around race was credited with advancing the healing of the city and furthering ongoing dialogue. Kaine would go on to serve as governor of Virginia (2006–10) and is currently serving as U.S. senator for Virginia (as of 2017).

In an effort to attract commercial business and conferences to the Richmond area, in 2002, the city remodeled and expanded the convention center, which reopened with improved facilities and more than 600,000 square feet of display space.

In 2004, L. Douglas Wilder became the first directly elected mayor in sixty years (getting 79 percent of the vote), and he began a campaign to reform city governance, revitalize the schools and confront many of Richmond's most difficult and persistent tensions. He spent a great deal of effort addressing issues of corruption and getting guns off the street and reducing gun violence.

Richmond in the twenty-first century has seen a significant number of transplants from other parts of the country, including a great many from the metropolitan areas along the Interstate 95 corridor. Nonetheless, many old Richmond families remain strongly represented in older and newer neighborhoods. Richmond has also been the beneficiary of a growing international and migrant influx, rendering it more diverse than it has ever been in its history.

Richmond Businesses—Rise and Fall

Several prominent businesses that flourished in the city deserve some mention, as they added greatly to the city's prosperity during this period. In 1989, A.H. Robins Pharmaceutical Company, in bankruptcy due to the Dalkon Shield product, was sold to American Home Products. Thus ended a remarkable Richmond company whose primary owners contributed much to institutions in the city. LandAmerica Corporation, the parent of Lawyers Title Insurance, founded in 1925, went bankrupt in 2009, along with S&K Famous Brands (men's clothing) and Circuit City.

Other businesses whose headquarters were in Richmond but continue to have operations here are part of other companies now. These include Reynolds Metals (bought by Alcoa), Ukrops Supermarket (bought by Martin's division of Ahold Corporation), Crestar (now part of Suntrust Financial), James River Paper (part of Georgia-Pacific today) and the old First and Merchants Bank, which today is part of Bank of America. These mergers are examples of robust Richmond enterprises sought by other companies. Another great story, too big to cover here, was the astounding accomplishments of the Gottwald family, starting with the founding of Albemarle Paper in 1887. Suffice it to say that Albemarle gobbled up the much larger Ethyl Corporation in 1962 and today commands Gambles Hill with distinctive white brick buildings. The corporation today goes primarily under the names NewMarket (Ethyl is a subsidiary), Albemarle and Tredegar—all separate corporations. The wealth the Gottwalds created for themselves and Richmonders who owned stock in the various companies is a legend yet to be widely told.

Recent Richmond Points of Interest and Activities

Richmond is on a tear, with improvements to its city life and culture in the twenty-first century. A new statue to Maggie L. Walker stands at West Broad and Adams Streets. The Black History Museum, opened in 1991, is open to the public in the historic Leigh Street Armory. The Virginia Holocaust Museum opened in 1997 and operates now at 2000 East Cary Street. The Tredegar Iron Works at 500 Tredegar Street is part of the American Civil War Museum, which includes Appomattox Court House and the White

House of the Confederacy. In 1987, Lewis Ginter Botanical Gardens (1800 Lakeside Avenue) opened to the public. The will of Grace Arents, niece of Lewis Ginter, left her estate to the City of Richmond upon the death of her companion, Mary Garland, who lived until 1966. The city used the property as a nursery for city trees until a group of citizens, including Lora Robins, wife of the late E. Claiborne Robins, pressed the city to create the gardens. This is another example of a long series of private initiatives over Richmond's history to create public spaces.

In the 1970s, Mitchell Kambis, a realtor and developer, began renovation of the Empire Theater in a section of Broad Street that had been given up for dead. He was a pioneer in this area. It was later purchased by Theater IV, now the Virginia Repertory Theatre. After additional renovations, it is now the November Theater. It takes many hands to move the needle of Richmond renovation. We previously mentioned the renovation of the National Theater downtown.

There is a festival to some culture or activity almost every weekend around the city. One of the largest events in the city is the Richmond Folk Festival each October. Some random examples of activities are Arts in the Park, the Greek Festival, Richmond Jazz Fest, the Filipino Festival and the Carytown Watermelon Festival. There are film festivals, beer and wine festivals, artistic festivals and food festivals. They are not hard to find. The north side of Broad Street has become a centerpiece of Richmond art galleries and upscale shops and eateries extending over into Jackson Ward. A recently revitalized area is Scott's Addition, an area bounded by the Boulevard on the east and Broad Street on the south. It got its name from Major General Winfield Scott, who received the property in 1817 when he married Elizabeth Mayo (from an aristocratic Richmond family.) Ironically, he was a Union general during the Civil War and developed the blockade strategy for the Union navy. The area became known as Scott's Addition as part of the survey that occurred when Richmond annexed the parcel in the early twentieth century. It was a light-industrial area that is being converted to other uses. It is home to the Richmond Triangle Players and many breweries and apartments.

In the twenty-first century, developers began to convert the buildings that are known as Tobacco Row into loft apartments. These are highly sought after. These warehouses were constructed in the early twentieth century solely to manufacture tobacco products. Thousands of Richmonders made their livings from working here. So much production took place that there was a sweet smell in the air of the freshly chopped leaves. The tenants are largely the new urban workers who have found jobs in financial, retail, advertising

Empire Theater/Theater IV, Broad Street, circa 1970. Public domain.

River Lofts, Carolina Building, circa 1900, today Tobacco Row Condominiums. *Photo by Misti Nolen.*

American Cigar Company, 1901, today Tobacco Row Condominiums. *Photo by Misti Nolen.*

and other white-collar jobs. They prefer to live in the city, since there are so many more activities in town than during the period 1975–2000.

In 2016, Levar Stoney was elected mayor of Richmond with an agenda to revitalize the public schools, balance the city's budget and move the city forward on issues related to inequality. Mayor Stoney said, "I campaigned on a platform of bringing accountability to City Hall, working collaboratively to address our educational needs and striving to overcome our historic divides. The goal is to build one Richmond—a city that works, and works together—to make life better for all residents." Richmond's history remains complicated and sometimes difficult. Even in the present, issues such as relationships with the neighboring counties, variability in quality and physical plant of city schools, uneven economic growth and disagreement about the best urban policies means that nothing is certain. But what can be said with great confidence and much past evidence to support it is that Richmond's history is amazingly diverse, unexpected, full of surprises and an open book to visitors as well as to permanent residents. They can reasonably expect that the future holds more of the same richness and possibility.

LIST OF MAYORS OF THE CITY

LIST OF MAYORS OF THE CITY

APPOINTED MAYORS (1782–1853)

Name	Political Party	Term Start	Term End
William Foushee Sr.		July 3, 1782	June 30, 1783
John J. Beckley		July 1, 1783	July 6, 1784
Robert Mitchell		July 7, 1784	1785
John Harvie		1785	1786
William Pennock		December 10, 1786	1786
Richard Adams Jr.		1786	February 21, 1788
John J. Beckley		February 22, 1788	March 9, 1789

Name	Political Party	Term Start	Term End
Alexander McRobert		March 10, 1789	March 9, 1790
Robert Boyd		March 10, 1790	1790
George Nicolson		1790	December 12, 1790
Robert Mitchell		December 13, 1790	1791
John Barrett		1791	1792
Robert Mitchell		1792	1793
John Barrett		1793	1794
Robert Mitchell		1794	1795
Andrew Dunscomb		1795	1796
Robert Mitchell		1796	1797
James McClurg		1797	1798
John Barrett		1798	1799
George Nicholson		1799	1800
James McClurg		1800	1801
William Richardson		1801	1802
John Foster		1802	1803
James McClurg		1803	1804
Robert Mitchell		1804	1805
William DuVal		1805	1806
Edward Carrington		1806	1810
David Bullock		1810	1811
Benjamin Tate		1811	1812
Thomas Wilson		1812	1813
John Greenhow		1813	1814
Thomas Wilson		1814	1815
Robert Gamble		1815	1816

Name	Political Party	Term Start	Term End
Thomas Wilson		1816	1817
William H. Fitzwhylson		1817	1818
Thomas Wilson		1818	May 4, 1818
Francis Wicker (acting)		May 5, 1818	1819
John Adams		1819	1826
Joseph Tate		1826	1839
Francis Wicker		1839	1840
William Lambert	Democrat	1840	March 24, 1852
Samuel C. Pulliam	Democrat	March 25, 1852	1853

POPULARLY ELECTED MAYORS (1853–1948)

Name	Political Party	Term Start	Term End
Joseph C. Mayo	Democrat	1853	April 3, 1865
Fall of Richmond (April 3, 1865) City under federal authority until appointment of David Saunders as mayor			
David J. Saunders Sr.	Democrat	July 3, 1865	April 6, 1866
Joseph C. Mayo	Democrat	April 7, 1866	May 4, 1868
George Chahoon	Republican	May 6, 1868	March 15, 1870
Henry K. Ellyson	Democrat	March 16, 1870	June 30, 1871
Anthony M. Keiley	Democrat	July 1, 1871	June 30, 1876
William C. Carrington	Democrat	July 1, 1876	June 30, 1888
James Taylor Ellyson	Democrat	July 1, 1888	June 30, 1894

Name	Political Party	Term Start	Term End
Richard M. Taylor	Democrat	July 1, 1894	1904
Carlton McCarthy	Democrat	September 1, 1904	August 31, 1908
David C. Richardson	Democrat	September 1, 1908	September 3, 1912
George Ainslie	Democrat	September 4, 1912	1924
John Fulmer Bright	Democrat	1924	1940
Gordon Barbour Ambler	Democrat	1940	1944
William C. Herbert	Democrat	1944	September 10, 1946

CITY COUNCIL–APPOINTED MAYORS (1948–2005)

Name	Political Party	Term Start	Term End
Horace H. Edwards	Democrat	September 11, 1946	1948
W. Stirling King	Democrat	1948	1950
T. Nelson Parker	Democrat	1950	1952
Edward E. Haddock	Democrat	1952	1954
Thomas P. Bryan	Democrat	1954	1956
F. Henry Garber	Democrat	1956	1958
A. Scott Anderson	Democrat	1958	1960
Claude W. Woodward	Democrat	1960	1962
Eleanor P. Sheppard	Democrat	July 1, 1962	June 30, 1964
Morrill Martin Crowe	Democrat	July 1, 1964	June 30, 1968

Name	Political Party	Term Start	Term End
Philip J. Bagley Jr.	Democrat	July 1, 1968	June 30, 1970
Thomas J. Bliley Jr.	Democrat	July 1, 1970	March 7, 1977
Henry L. Marsh III	Democrat	March 8, 1977	June 30, 1982
Roy A. West	Democrat	July 1, 1982	June 30, 1988
Geline B. Williams	Republican	July 1, 1988	June 30, 1990
Walter T. Kenney Sr.	Democrat	July 1, 1990	June 30, 1994
Leonidas B. Young II	Democrat	July 1, 1994	June 30, 1996
Larry E. Chavis	Democrat	July 1, 1996	June 30, 1998
Timothy M. Kaine	Democrat	July 1, 1998	September 10, 2001
Rudolph C. McCollum Jr.	Democrat	September 11, 2001	January 1, 2005

POPULARLY ELECTED MAYORS (SINCE 2005)

Name	Political Party	Term Start	Term End
L. Douglas Wilder	Democrat	January 2, 2005	January 1, 2009
Dwight C. Jones	Democrat	January 1, 2009	December 31, 2016
Levar Stoney	Democrat	December 31, 2016	Incumbent

SELECTED BIBLIOGRAPHY

Books and Articles

Berry, Thomas S. "The Rise of Flour Milling in Richmond." *Virginia Magazine of History and Biography* 78, no. 4 (1970).

Campbell, Benjamin. *Richmond's Unhealed History*. Richmond, VA: Brandylane Publishers, 2012.

Committee of Twenty-Four. "Report: For the Purpose of Devising Means to Suppress the Vice of Gambling in This City." Richmond, VA: T.W. White, 1833.

Dabney, Virginius. *Richmond: The Story of a City*. New York: Doubleday, 1976.

Heinemann, Ronald L. *Depression and New Deal in Virginia: The Enduring Dominion*. Charlottesville: University of Virginia Press, 1983.

Lankford, Nelson. *Richmond Burning: The Last Days of the Confederate Capital*. New York: Viking, 2002.

Lee, Marguerite D. *Virginia Ghosts*. Berryville: Virginia Book Company, 1966.

Mahone, Kathryn Lynn. "The Irish Community in Antebellum Richmond, 1840–1860." Master's thesis, University of Richmond, 1986.

Manarin, Louis H., and Charles H. Peple. *The History of Henrico County*. N.p.: County of Henrico, 2011.

Meriwether, Stuart. "Colonel Ulric Dahlgren and Richmond's Union Underground." *Virginia Magazine of History and Biography* 72, no. 2 (1964): 152–204.

Ordinances of the Corporation of the City of Richmond and the Acts of the Assembly Relating Thereof. Richmond, VA: John Warrock, 1831.

Randolph, Lewis A., and Gayle T. Tate. *Rights for a Season: The Politics of Race, Class, and Gender in Richmond, Virginia*. Knoxville: University of Tennessee Press, 2003.

Reynolds, Donald E. *Editors Make War: Southern Newspapers in the Secession Crisis*. Nashville, TN: Vanderbilt University Press, 1970.

Richmond City Council, various.

Richmond city directories, various.

Richmond Civil War Centennial Committee. *Confederate Military Hospitals in Richmond*. Richmond, VA: RCWCC, 1964.

Richmond Times-Dispatch (various issues).

Sanford, James K., ed. *Richmond: Her Triumphs, Tragedies & Growth*. Richmond, VA: MRCC, 1975.

Taylor, Michael Eric. "The African-American Community of Richmond, Virginia: 1950–1956." Master's thesis, University of Richmond, 1994.

Thomas, Emory M. *The Confederate State of Richmond: A Biography of the Capital*. Baton Rouge: Louisiana State University Press, 1971.

Trammell, J. "Richmond's Belle Isle a Rival to Andersonville." *Washington Times*, August 31, 2002, B3.

———. "Richmond Slave Market Busy to End. Washington Times, February 12, 2005, D5.

———. *The Richmond Slave Trade*. Charleston, SC: The History Press, 2012.

———. "Travelers to Wartime Richmond Had a Wide Choice of Luxurious Hotels, Inns and Taverns." *America's Civil War* (September 1996).

Tyler-McGraw, Marie. *At the Falls: Richmond Virginia and its People*. Chapel Hill: University of North Carolina Press, 1994.

Virginia Magazine of History and Biography (various issues).

Websites

www.blackpast.org

www.coopercenter.org

www.encyclopediavirginia.org

www.historicjamestowne.org

www.historicrichmond.com

www.lva.virginia.gov/public/dvb

www.mdgorman.com

www.nps.gov

www.pbs.org

www.preservationvirginia.org
www.richmond.edu
www.richmond.gov
www.richmondrailroadmuseum.org
www.richmondtourguys.com
www.thevalentine.org
www.ushistory.com
www.vacanals.org
www.vahistorical.org
www.virginiageneralassembly.gov
www.virginiaplaces.org
www.wtvr.com

INDEX

ABOUT THE AUTHORS

Jack Trammell is an author, a professor of sociology and a researcher. His recent books include *The Fourth Branch of Government: We the People* and *The Richmond Slave Trade*. He is a recognized voice of Appalachia and a scholar of social history, disability and research design. He can be reached at jacktrammell@yahoo.com.

Guy Terrell is a project manager, writer and educator. He recently coauthored *The Fourth Branch of Government: We the People* with Jack Trammell. He earned his BA at Hampden-Sydney College, an MBA from George Mason University and an M.S. in Information Systems from Virginia Commonwealth University, where he earned the Dean's Scholar Award. He has published poetry and is a past president and treasurer of the Poetry Society of Virginia (PSV). He has published poetry in journals and won prizes for his poems.